SECRET BURY ST EDMUNDS

Martyn Taylor

AMBERLEY

First published 2014

Amberley Publishing
The Hill, Stroud, Gloucestershire, GL5 4EP
www.amberley-books.com

Copyright © Martyn Taylor, 2014

The right of Martyn Taylor to be identified as the
Author of this work has been asserted in accordance
with the Copyrights, Designs and Patents Act 1988.

ISBN 978 1 4456 4046 4 (print)
ISBN 978 1 4456 4079 2 (ebook)

British Library Cataloguing in Publication Data.
A catalogue record for this book is available from the
British Library.

Typesetting by Amberley Publishing.
Printed in Great Britain.

Introduction

If the wonderful abbey church of St Edmundsbury had not been despoiled by Henry VIII, Bury St Edmunds would not be the pleasing town it is today. As the church was comparable to York, Durham or Lincoln, we would now be a metropolis, a city. Instead, what we are left with is a shell, a mere glimpse of what once was one of the greatest abbey churches in the country!

Over more than 1,000 years of history, Bury St Edmunds has acquired a mix of the unexpected, strange, weird and wonderful examples of buildings and tales of the people associated with them.

The old adage of looking up when exploring any town is true to Bury St Edmunds; for 'it is up' where many interesting gems of architecture, embellishments and ornamentations will be found.

Growing up in post Second World War Bury St Edmunds, I was taught nothing about its past, only acquiring a love of its history later in life, with my wife sharing my interest. As time went on, I realised, as an outward-going person, I wanted to share my love of Bury St Edmunds, hence why I became a tour guide of the town. I was very fortunate to meet likeminded people who have helped me to gain more knowledge of the town's history and heritage. For many years, I have been recording an archive called 'Written in Stone', which relates to the inscriptions on the walls in the town. This led to 'Have you Noticed', a talk on the quirkier items about the town; and what a wealth we have here! While buildings are obviously a link to the past and the people connected with them, retelling some of their stories brings history to life.

However, Bury is not just about its medieval core; the growth of the town in the twentieth century was slow, housing estates gradually spreading onto the outskirts. The coming of much needed industry brought in skilled labour that required housing, with the London overspill initiative fulfilling this. Today, the town looks towards more expansion, with Vision 31 setting out how Bury St Edmunds will look in years to come.

Historians have written books and journals covering many subjects about Bury St Edmunds. Some are academic, while others are more accessible, easier to read.

Whatever formats these are produced in, they offer an insight into our past. From the very beginning there have been various opinions about the history of Bury, and the many contributions by people who have lived or visited here.

The reader is always looking for that interesting snippet, that titbit of information that brings them to exclaim 'well I never knew that'. That is the aim of this book, to put forward that little bit extra about something that has always been taken for granted or never even known.

Many of the stories told within have never been published before, with the pictures enhancing them. These eclectic stories should give residents a feeling of how lucky they are to live in such a wonderful, vibrant town, with visitors longing to come back for more.

Acknowledgements

The author appreciates the help and assistance rendered by the following people and organisations: Anglia Newspapers Ltd, David Addy, Isobel Ashton, John Boughton, Bury Heritage Guides, Bury Past & Present Society, Edward Cobbold, Brian Coley, Nigel Finch, Adrian Frost, Mike Jackson, Kevin Pulford, Suffolk Records Office, St Edmundsbury Council special collections department, Gordon Wagstaff, E. Warren, Roger Waters, and a big thank you to my wife, Sandie. To those not mentioned, they know who they are. Thank you.

The Hidden Gardens of Bury

This fundraising initiative for St Nicholas Hospice started in 1987, when a hospice committee fundraiser, Tricia Mellor, decided to open her garden to the public. It occurred to her that, if members of the public were willing to traipse through her meagre plot, others could be persuaded to open their gardens up as well. And they did! The name 'The Hidden Gardens of Bury' was adopted, and over £15,000 was raised in the first five years.

After Tricia retired, Isobel Ashton and Pam Whittingdale took over the reins. From day one, the gardens, which now open for one Sunday in June, were identified by the letters of the alphabet, A–Z, hence twenty-six. There are now over thirty involved! Planning starts months ahead. The scheme tries to keep within the old boundaries where the town gates were situated, so it is always possible to see as many gardens as you can during the opening hours of 11 a.m. until 5 p.m. Entrance to the wonderful secret gardens is by programme, on the day at the small marquee on Angel Hill, or in advance. When Pam retired, Isobel's co-partner became Elizabeth Barber-Lomax, and gradually it has evolved into a significant fundraising event, with sponsorship and even businesses taking part. Jill Carter, Dianne Knights and Sheila Blackmore are now the organisers. One great thing about Hidden Gardens are the visitors; their comments such as 'I never knew this was here', or 'I wish my garden was like this', inspires them to go forth with enthusiastic ideas for their own patch.

The garden hosts with inward warmth, sell their ice creams, cordials and cakes to help swell the hospice's much needed funds. The Hidden Gardens have now raised over a quarter of a million pounds since its inception, from thousands of people's contributions. A truly communal effort for a local charity.

Penny Street

Most of Long Brackland was renamed St John's Street, after the building of St John's church in 1841, the church a much needed addition to the town. Brackland, meaning broken ground, along with its counterpart, Short Brackland, was one of the least fashionable streets to live in. Brackland is mentioned from at least the late twelfth century, when one of its most famous inhabitants, Jocelin of Brakelond, a monk of St Edmundsbury abbey, lived here. He wrote a celebrated chronicle of life at the abbey, including the abbacy of one of its most charismatic abbots, Samson. Four years after, St John's church was consecrated in 1842, the railway came to Bury. Then, roughly three quarters of the way down the former Long Brackland, a new street was created named Ipswich Street, supposedly called because of the connection with the railway line from Ipswich. On the corner of this street, a beerhouse, the Brittania, opened in 1869. The last landlord of this no nonsense public house was Eric Bull, whose family had been associated with it for nearly fifty years. After this pub closed around 1980, the building became Brittania House, a hostel for the homeless.

At the top of St John's Street, on the corner with Brentgovel Street, was another pub called the Kings Head. An inn had been on this site from the early eighteenth century. One of its more colourful landlords was Eddie Hunt, Magic Circle magician; often he would do a trick before serving you a pint. When this pub closed in 1976, it was replaced with a Mothercare store. From the Kings Head to the Brittania, St John's Street acquired the nickname 'Penny Street', as they were the two sides of a pre-decimal penny.

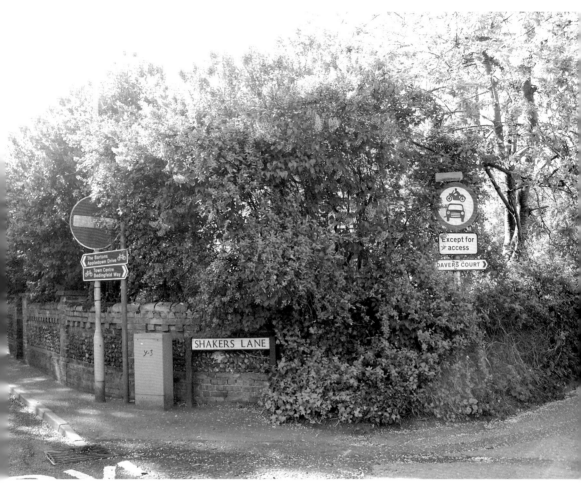

Shakers Lane

This narrow country lane once went from the top of Eastgate Street right through to Rougham Hill. As it is now no longer possible for vehicles to travel through here, it is a haven for flora and fauna.

The name Shakers derives from the word shackage. Lands where right of 'shackage' existed was connected to 'shack'. This was when gleaning could be carried out after a crop had been harvested, and probably dates back to medieval times when peasants could enter a field after harvest.

Undoubtedly, the fields in Shakers Lane had crops in the summer, and sheep were penned there to eat the leavings over winter. The term shackage has also come to mean moveable pens for sheep, as opposed to sheepfolds. As East Anglia was noted for its wool trade, large flocks of sheep were kept, their dung being beneficial for fertilising the soil. The common rights or permissions could only be given by the owner or occupier of the land, and these ancient rights had all but fallen into private hands by 1791. Following the Land Enclosure Acts, after 1801, the land commissioners responsible for implementing these did not need to report back to parliament, so country folk lost out further.

On Thomas Warren's map of 1791, Shakers Way, as it was then known, is shown as lined by several fields, and labelled as 'several shackages of Sir Wm Davers flock'. Today, on that site is a sheltered home for the elderly, appropriately called Davers Court. The Davers were prominent landowners in Bury St Edmunds, with their family seat at Rushbrooke. On several occasions they had provided one of the two MPs that Bury used to send to parliament (until 1885).

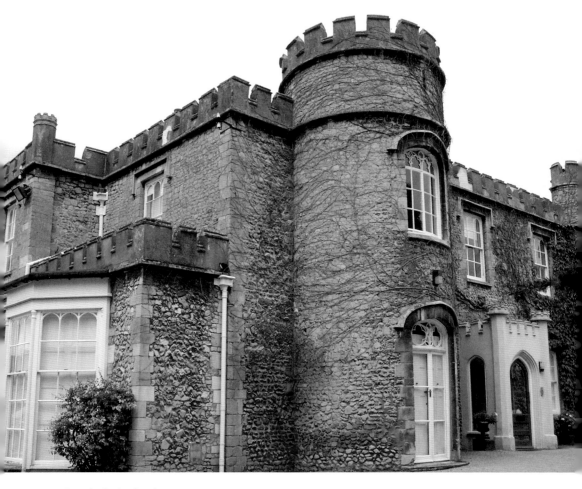

Bury's Only Castle

Bury St Edmunds did not need a castle to subdue its inhabitants when the Normans invaded in 1066, as it was already under their control through its French abbot, Abbot Baldwin.

However, in St Andrews Street South, there is a property called St Andrews Castle. According to Thomas Warren's maps of 1776 and 1791, the 'castle' was built during this period. An attorney, Ezekiel Sparke (1762–1816), was the owner of this so called '*strawberry gothick*' creation; it has a stone vaulted ceiling in the reception hall. In 1961, county archivist M. P. Statham refers to it as Sparke's Castle. Probably the first major build outside the town's medieval western defences – the Ditchway – it was built on land that once belonged to the Ray family who were prosperous yarn makers in the town. Orbell Ray died in 1768 and left his business to nephew James Oakes, who had entered the family firm aged sixteen. As the wool industry declined, Oakes got out and went into banking, with Ezekiel Sparke becoming his attorney.

The castellated walls of St Andrews later appealed to one George Boby, who lived there from 1865 to his death in 1890. George Boby ran a coalyard on Station Hill; called Boby Bros (Robert in name only). Robert had the very successful engineering works at St Andrews Ironworks, situated on Oakes former combing sheds. Bobys grew into one of the town's largest employers. In 1929, the Sisters of St Louis opened a convent school at the castle; it was granted Grammar School status in 1958, becoming a state-run Catholic school in 1971. The school left the castle in 1989 but still stayed on-site. The Active Business Centre opened a year later, and they are still here.

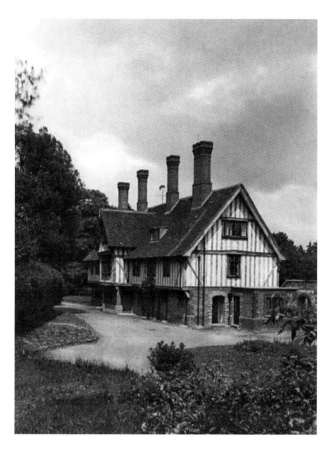

Hardwick Manor

When Dame Anne Cullum, the second wife of Thomas Gery Cullum, made her will, it included an entailment clause, whereby only male members of the family would be able to inherit the Hardwick Estate and its contents. Hardwick House, formerly an Elizabethan mansion but subsequently much altered, was set in enormous grounds.

Her step-grandson, George Gery Milner Gibson, had taken on the family name Cullum in 1878, enabling him to inherit. Unfortunately, there was no issue from him, this very cultured man never married and died in 1921. After his death, the crown seized the estate under the Intestate Act of 1884. In June 1924, the contents were sold and Hardwick was offered for sale; to be purchased by Mr Thomas Oakley of Luton and demolished in 1925. Much of the interior was reclaimed.

Financier Halford Hewitt from Kensington had Hardwick Manor created in 1925–27, after local timber merchants, who had purchased some of the estate for the timber, declined the former gardener's cottage.

Panelling and a staircase was used in the remodelling of Hardwick Manor in 1927, by local builder H. G. Frost, who lived nearby at Stonebridge. Kersey, Gale and Spooner were the notable architects who were responsible for St Paul's Anglican church at Southwark.

At one time, the extravagant Hewitt had eleven gardeners working on his gardens. He was also instrumental in setting up an eponymous national golf tournament for ex-pupils of public schools, played at the Royal Cinque Ports Golf Club in Deal; a competition that is still going today. Local builder, Leonard Sewell, colloquially known as Lennie, purchased Hardwick Manor in 1953 for a rumoured sum of £20,000. He later became Mayor of Bury St Edmunds. For many years, the annual Hardwick Fête, in aid of the hospital, was a popular attraction.

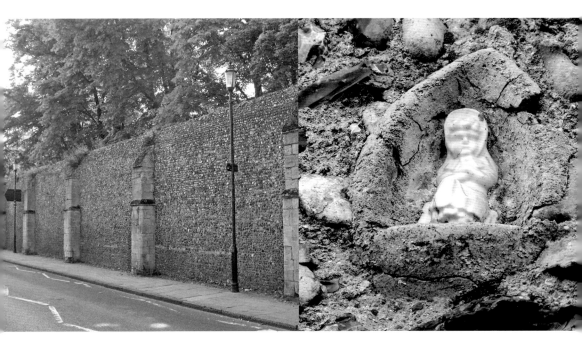

The Ceramic Doll

I wrote about this curious doll in a publication called *Peepholes Two*, with a history group I belong to – Bury Heritage Guides. It is such an unusual subject I have decided to cover it again. The Department of the Environment (formerly Ministry of Public Buildings and Works) was taken over in 1983 by a new agency, English Heritage. It was around this changeover of responsibility for our past, 1984, that workmen, cleaning down the north precinct wall of the abbey of St Edmundsbury, made a startling discovery. Hidden among the flint and mortar was 'a curious doll'. Approximately 12 centimetres/ 5 inches high, this small statuette is set in an arched niche made from either mortar or cement. The doll (probably ceramic) is a female figure dressed in eighteenth-century costume, complete with petticoat and bonnet, and has its arms crossed clutching an open book.

The niche is 3 metres/10 feet up high, and there is the date on it of 1777, though this could be wrong due to the passage of time and the ravages of the seasons. Curiously, if this date of 1777 is correct, it coincides with a date stone on a nearby house, No. 28 Mustow Street. This house was renovated in 1981 by the Town Trust.

Mercifully, the high location of the Ceramic Doll is protecting it. Now questions have to be asked; is this a genuine figurine from the past, or a case of some wag playing games with us?

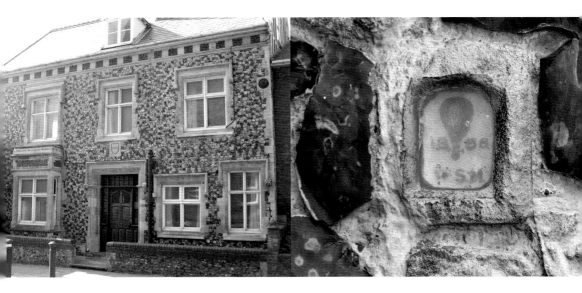

Balloon in a Wall

Hidden away, among the knapped flints at the front of No. 1 Westgate Street, is a most unusual historical object, a small drawing of a balloon. Shielded behind glass, it shows a hot air balloon with a basket slung beneath it, with two flags flying from the basket. This is where it gets a little complicated; there is a date (possibly 1858 or 1868), then what looks like the letters W. S. M. Why this depiction is here is a mystery? The fine building it is on was built in 1884 by distinguished builder Lot Jackaman, to be his own house. Lot had come to Bury from Norfolk to work as foreman to Thomas Farrow, the restorer of the Norman Tower and builder of Savings Bank House; this was all in the 1840s.

Lot was quite an extraordinary man; while working on the Norman Tower he saved a man's life, receiving a silver cup in recognition of his good deed. In 1861, by now running his own business, he built the Corn Exchange. No. 1 has all sorts of embellishments and building styles on it, including, under the eaves of the gable end, 'waste not want not' written in stone, with a pair of masonic dividers, also in stone. Lot died in 1885 aged seventy.

The only connection to early balloon flight that Bury had was the flight taken by a Capt Poole in 1785. The captain took off from the abbey site (no gardens then), watched by thousands, eventually landing at Earl Soham, a distance of over 23 miles as the crow flies. He returned to Bury by carriage at midnight in triumph.

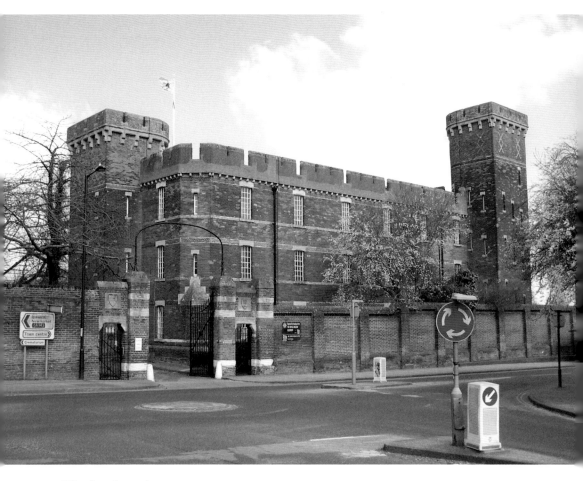

Gibraltar Barracks

The Gibraltar Barracks are named after the 12th Regiment of Foot's (Suffolk Regiment) heroic defence of the rock between 1779 and 1783. All that is left is the keep and curtain walls. The 16–20 acre site, once part of St Peters Barn Farm, was purchased in 1875 for just over £4,000, from the Governors of the Bury Grammar School, by the War Department.

One of only nine surviving examples in the country, it opened in 1878 and was designed by Maj. Seddon RE. Costing around £66,000, it had up-to-date facilities, including married men's quarters, a canteen, gymnasium, reading room and officers' and other rank's messes. The actual billets for the men numbered 250.

Marking the perimeter of the site are stones with W. D. on them for the purchasers. Once, the large parade ground used to echo the marching boots of soldiers, especially on Daffodil Sunday and Minden Day (1 August). It now it resonates to the sound of students and the motor vehicle. The Suffolk Regiment merged with The Norfolk Regiment in 1959, to become The Royal Anglian Regiment, with the barracks closing in 1960. As Bury was no longer a garrison town, the barracks were chosen to be the new location of the West Suffolk College.

The college had originated at the Silver Jubilee School, around the corner in Grove Road, in 1951; seven years later, a decision was made to move to new premises, opening in May 1961. Now part of the University Campus of Suffolk, the college has had many extensions over the years, but 2013 saw the tired 1960s building encased in a new façade, winning awards for its complete transformation. The keep now houses the regimental museum.

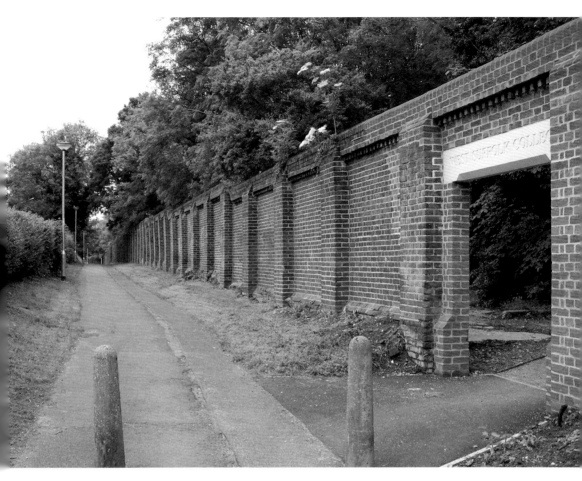

Beetons Footpath

This was once the only direct route from the western side of town to the northern side. Then no more than a dirt track, it left the corner of the Gibraltar Barracks in Newmarket Road, with bramble bushes running parallel, past the barracks firing range, into open countryside, until it met the unmanned level crossing. After going over this at your peril, you skirted open fields passing Klondyke Cottages on your right, until you met the top of Tollgate Lane, where the Greengage PH was built in 1957. This was on land formerly in the parish of Fornham All Saints, and previously owned by the Gage family of Hengrave Hall – they had brought the greengage fruit to England.

The Mildenhall Estate was the first expansion outside the 'Banleuca', the medieval boundary of Bury St Edmunds. One of the boundary cross bases, the plague stone, originally stood at the entrance to Beetons footpath in Newmarket Road. Much moved since, it now stands outside the nearby college. Back in 1630, the land here was called Hamerland, a corruption of an earlier name, Hamerlound. Once owned by Bury Grammar School, this land was rented by a George Beeton until 1836, when he was asked to give up the tenancy. Subsequently, two acres of his St Peters Barn Farm were purchased by the Chesterford & Newmarket Railway Co. for £625 in 1853, thus enabling the Bury to Newmarket line to be completed – hence the rail crossing.

In 1970, an underpass costing £106,000 meant not only the railway crossed over the new road now called Beetons Way, so did the new A14 bypass. Nearby, more development followed, like the Howard Estate. Beetons Way is now a major road link from Mildenhall Road to Newmarket Road.

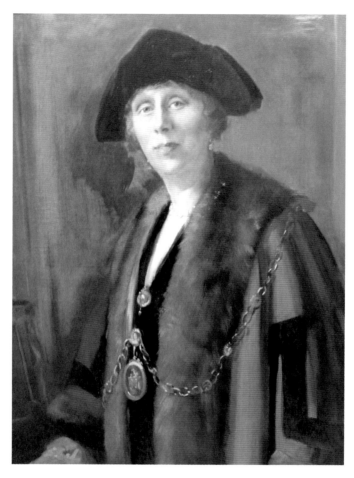

Our First Female Mayor

The first actual mayor of Bury St Edmunds was Francis King Eagle, in 1836, but the town had to wait nearly 100 years before a woman was elected – Eva Paulina Greene.

The daughter of Revd Sir George Boughey, rector of All Saints, Forton, Staffordshire, she married John Woolaston Greene of local solicitors Greene & Greene in 1912. John and Eva lived at The Panels, now the Farmers Club in Bury St Edmunds. They had a daughter, Paulina, in 1917, and both parents were joyous at having a child so late in life – John was forty-eight, Eva thirty-nine. Tragically, Paulina died nearly aged four. The year she died (1921), Eva decided to go into local politics, and became an elected borough and county councillor.

Sadly, John died in 1925 and was buried at Thurston. In 1927/28 Eva became mayor, and again in 1931/32. In 1930, celebrated local artist Rose Mead painted Eva's portrait in oils. Dressed formally in mayoral robes and chain of office, this impressive picture is in St Edmundsbury Borough Council's collection.

In memory of their daughter, Eva gave an altar cross to the cathedral in 1931. On it were seed pearls and garnets from the little girl's bracelet, and matching candlesticks followed in 1955. A year later, Eva went back to the family estate to help run it – mind you she was no spring chicken herself by then.

She died in 1973 at the ripe old age of ninety-five, and is buried with her husband and daughter at St Peters church, Thurston. Not only was she a great supporter of women's and children's wellbeing, but that of civic duty as well.

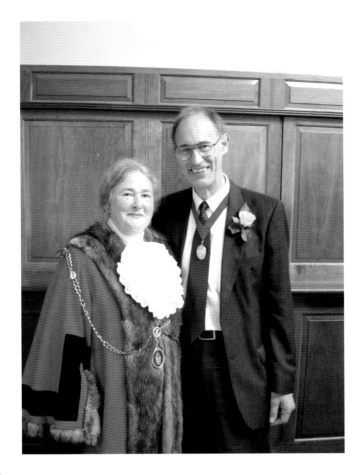

Civic Duty

'Incy Wincey Spider', is a scout campfire song inspired by Stanley Ince, who was pivotal in the early days of the Boy Scout movement. He became friendly with Robert Baden-Powell and founded the South Hackney Scout Troop in 1911. As a result of the First World War, he contracted polio, a condition that left him with very spindly, spidery legs, hence the song. He died in 1941 aged fifty-five, eight months after receiving the OBE for services to scouting.

A year later his daughter, Enid Mary Ince, married Harry Marsh. As a young girl she went to Hawkedon, Suffolk, to convalesce after an illness. Life on Harry's family farm – Hungriff Hall – was vastly different to where she came from. Enid, born on the day the First World War broke out, had a very interesting job before marrying – for a while she was secretary to Air Marshal Sir Arthur 'Bomber' Harris. After the war, she and Harry ended up at Bury St Edmunds, moving into Albert Crescent in 1951, their home for many years. Enid, a gifted artist, passed away in Manson House retirement home in 2009.

Harry predeceased Enid in 1998 aged eighty-seven. A passionate supporter of the town, he was elected to the Borough Council in 1962 to fight demolition of the Corn Exchange and later the destruction of St John's Street, a proposal he was vehemently opposed to. Harry Marsh was also instrumental in having the press cover council meetings; he became mayor in 1983/84. His example led to one of his three daughters, Margaret, to wear the mayoral robes. She and her husband, Roger Charlesworth, purchased the Albert Crescent home in 2002. Becoming a borough councillor in 2003, and subsequently mayor, she became a Magna Carta Trustee and chairman of Magna Carta 800, a Bury Society sub-committee, formative in bringing the Lincoln Magna Carta to Bury St Edmunds in 2014.

The Ditchway

This was a deep ditch with an earthen rampart that ran all the way from the Westgate (Butts corner) up St Andrews Street South, down St Andrews Street North, until it met with the Tayfen. Then, as now, this part of the town was as its name suggests – a waterlogged area which acted as natural defences. The Lark and the Linnet also acted thus.

In 1968, an archaeological dig in Tayfen Road, close to the site of the Northgate (now a traffic roundabout), also identified the construction of a ditch and earthen rampart, though no actual wall was found. A great benefactor of the town, King Canute, according to chronicler, William of Malmesbury, had a protective ditch excavated to protect the town. In the twelfth century, walls were supposed to have been added, but no traces of these remain.

During 2012/13, building works in St Andrew's Street South allowed archaeologists to cut a section into the ditch. It would seem that, after the Ditchway had fallen into disuse, it was used for disposal of sewerage and rubbish from the houses in Guildhall Street. The Dycheweye (its medieval name), with its embankment, was part of the western defences of Bury St Edmunds; nothing now survives above ground. Well, it does in a sense, because there are sloping forecourts to Curry's footwear repairers, at the rear of the Hunter Club and Black Boy in St Andrew's Street South. Carrying along into St Andrew's Street North, there are slopes in Sergeants Walk and to the rear of the Bushel. These slopes go up and over, as in the case of Sergeants Walk and the Bushel into St John's Street. Nearby St John's Place has no such feature.

A Dragon's Tooth

With the miraculous withdrawal of British troops from Dunkirk in 1940, Britain braced for a German invasion. As with countless other places, Bury St Edmunds had put in place a series of defensive measures, and the 2nd Suffolk battalion of the Home Guard played a large part in these local defences. The town was ringed with an anti-tank ditch and, at strategic points, concrete pill boxes were situated. Perhaps the most fortified area of the town was on the eastern side, from Rougham Hill across No-Man's Meadow, past today's St James school, and then onto the sugar beet factory.

If, in the event of an invasion this outer ring was penetrated, the last stand would take place at the 'Inner Keep'. This area was approximately from Mill Road, to St Andrew's Street South, the Cattle Market (today's Arc) and King's Road.

The main entrances/exits to the town were designated as 'Green' enforcement roads, that is to say road blocks would operate here. They were Eastgate, Southgate, Rougham Road, by the Spread Eagle PH, and Newmarket Road. Although Fornham Road was not designated as 'Green', there is a relic of a road block in the shape of pimple, a concrete pyramid also known as a dragon's tooth, on the corner with Thingoe Hill. It was thought that traffic should flow through this area' and only in the most severe alerts would this pimple and others like it be dragged into the road.

At around 2 feet tall with a 3-foot square base, any vehicle, such as a tank, trying to get over them, would see their under carriage vulnerable and susceptible to anti-tank weapons.

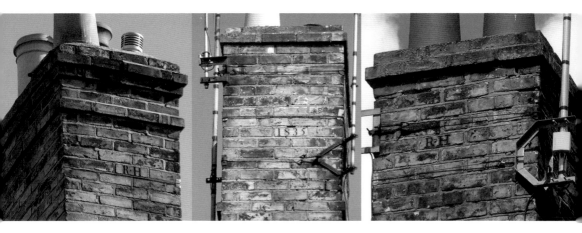

Chimney Letters

Opposite the St Edmunds church in Westgate Street is a terrace of eight houses. Once, all of Suffolk white-brick construction, they are now a mixture of rendering and different colours. The properties were built in 1835, the topping out, obviously on the chimneys. This is where a clue to the builder of the terrace is, for on these chimneys are the letters RH and the date of 1835 actually etched into the brickwork! Evidently, according to one former resident, the inscriptions are inside the loft space as well. R. H., or to be precise Robert Harvey, ran a bakery business, trading as Robert Harvey & Son from No. 45 Guildhall Street, literally round the corner from the terrace, and the shopfront is still there. The Harveys were living at No. 24 Westgate Street, so were well placed to keep an eye on the progress of their building project.

No. 24 has an interesting history; it was at once owned by John Corsbie, an eighteenth-century wool merchant. He rented it out to a friend, yarn maker William Buck. After Corsbie sold it to Philip Bowes Broke, Buck continued renting it, eventually buying the freehold around 1789. Leaving the wool trade, Buck went into partnership with Benjamin Greene in the business of brewing. Buck died in 1819, and a Thomas Smith then owned it for a while, before the Harveys rented it. By now it was known as Turret Close. Robert Harvey, styling himself as Gent, eventually moved to No. 7 Westgate Street near the Theatre Royal.

Turret Close opened as St Nicholas Hospice in 1986, but after a successful appeal, £2.5 million was raised for a new unit at Hardwick in 1993. The name Corsbie is still remembered, today with Corsbie Close, part of Cathedral Meadows off Cullum Road.

V R Letters

This wall post box, down by the Deanery (Clopton's Asylum) in the Great Churchyard, is one of only two Victorian post boxes left in the town; the other, a more familiar pillar box is opposite St Mary's in Crown Street. A third disappeared after a wall in which the box was situated in Cannon Street was found to be unstable and was taken down.

Post boxes were once painted green, but, in 1884, the colour red was adopted for general use. In 2012, Royal Mail painted over 100 post boxes throughout the country, a gold colour, to celebrate the achievements of the Olympic and Paralympic medal winners.

Before post boxes, letters were handed to a post boy, who sounded a bell on his collecting round, or handed it in at a branch of the Postal service. Then, in 1840, three years after Victoria ascended the throne, Roland Hill introduced the first pre-paid adhesive stamp. In Bury, there were two small post offices in the town, before a larger one opened in No. 51 Abbeygate Street in 1881.

When this was deemed to be too small, the present day post office, affectionately known by many at one time as 'the General', was built on the site of the Bell Hotel in 1895. The adjacent narrow Bell Arcade was a reminder of its previous life, it becoming, in recent years, Market Thoroughfare. This was where the link to the Arc shopping complex was supposed to be, but never happened. The post office, with its royal coat of arms, is a fine example of a Victorian public building.

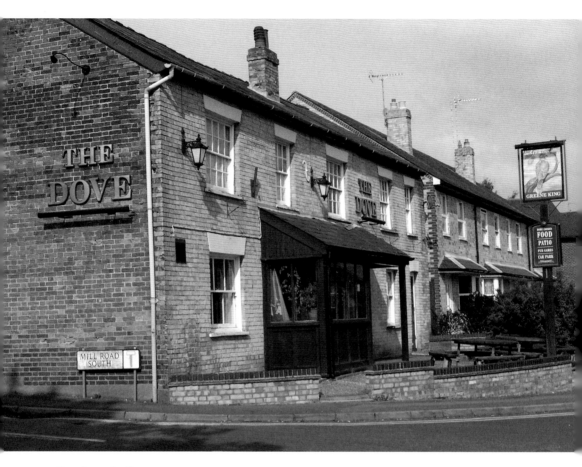

Death at the Dove

The Dove, a beerhouse from around 1837, received its full licence in 1929. Four years earlier, on 30 October, a tragedy occurred when the landlord Alfred Russell committed suicide.

On the day of this sad occasion, at around 8.15 a.m., his daughter, Rebecca, made him a cup of tea, and after drinking it he went upstairs saying he didn't feel like working that day. After finishing some chores she didn't see her father around. Her brother Jack arrived about 11 a.m., and he went upstairs to see if his father wanted any dinner, finding the door locked. Rebecca said he probably didn't want to eat. However, after opening up at 5 p.m., and still no sign of Alfred, she went up after an hour to find the door still locked. Worried, she went to her Uncle Thomas's house and he came immediately, forced the door open and found his brother hanging by a cord from the coat peg on the door, a chair nearby. He was cut down and laid on the bed. At the subsequent inquest, held in a small room at the Dove, the coroner asked the family if Alfred had any financial worries, as an unpaid bill for £5 was found on him. It was then disclosed that Alfred was very concerned about his wife's mental state, as she was in Ipswich Asylum.

Dr Stork, the medical officer of health, said he attended to the deceased around 7 p.m. on the previous evening, and death must have occurred more than eight hours earlier. Rebecca told the coroner, Mr George Carter, that her father was worried about falling trade. Mr Burton, for the Dove's owners, Greene King, said the Russell family were good tenants over a number of years.

The coroner's verdict was suicide while in a state of unsound mind. Alfred was just fifty-two.

Mary Davers' Burial

The Davers were a notable Bury family with plantations in Barbados and who, by judicious marriages and inheritances, grew to be wealthy landowners in the Bury St Edmunds area. Entwined with the Bristols of Ickworth, the baronets represented Bury St Edmunds in Parliament on many occasions. The family seat was Rushbrook Hall, which was to be consumed by fire in 1961 when derelict.

What caused the family members' lack of longevity can only be surmised – suffice to say that many died in infancy and several committed suicide.

One such event was when Henry Davers shot himself while at sea in 1759, a trait that was again shown seven years later when Thomas Davers shot himself, reputedly in a glasshouse at the rear of the Davers' townhouse on Angel Hill, now Abbey House.

Against this background of instability and insecurity, it was no wonder that family member Mary Davers left a strange instruction in her will. Mary had lived at the townhouse and died in 1805, bucking the family trend aged around seventy-five. She had never married, which probably contributed to her great age by Davers' terms!

Mary Davers' will stipulated that she was to be buried in a grave 12 feet down – she probably had a morbid fear of being stolen by resurrectionists, or body thieves.

Hanging had, for many years, supplied bodies for anatomisation; however, with the new enlightened sciences there were not enough cadavers to satisfy the demand, as the number of capital offences diminished.

Hence why the likes of Burke and Hare were providing fresh corpses in 1828 by murdering their victims!

The Grey Lady Ghost

Do you believe in ghosts? If you don't you won't see one. That is the standard Q&A for the existence of ethereal beings. This particular spectre, reputed to haunt the Great Churchyard, is the nun, Maude Carew.

In 1447, Henry VI summoned Parliament to Bury, his uncle and former guardian, Duke Humphrey Plantagenet, was to be charged with treason. Lodgings were at St Saviour's (in Fornham Road). While here, he was found dead, reputably poisoned; while others say by being smothered by a bolster, the official verdict is apoplexy – a stroke.

Rumours abounded that the good duke was to defend himself by telling of Henry's wife Margaret's affair with another, Sir Roger Drury.

Margaret took Maude into her confidence, explaining the situation, but Maude then told the queen of her love for the same man! Unbeknown to them both, Roger had entered Bury Abbey to forget both affairs, and had assumed the identity of Brother Bernard.

Maude had entered the Babwell Friary to forget about him. Poor Maude was persuaded to assassinate Humphrey by entering Humphrey's bedchamber via a secret tunnel and poisoning him while he slept. Unfortunately for her, she spilt some on herself. The dying Maude found Brother Bernard, aka Roger Drury, and blurted out the whole story. Horrified, he cursed Maud, who was doomed to walk the precincts of the Abbey for evermore.

The good Duke dying is factual, the rest fantasy, a story made up by Margeretta Greene, who lived in a house built into the ruins of the abbey's west front. In 1861, she wrote a story called *The Secret Disclosed*, based on a document she said was found in the West Front's ancient walls. The names of Drury and Carew are based on actual people, and monuments to them are in St Mary's.

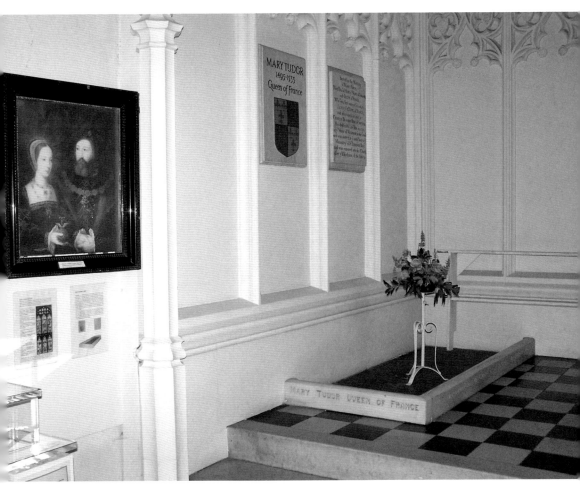

Lady Jane Grey

The legendary nine-day queen of England had connections to Bury St Edmunds. She was the granddaughter of Mary Rose Tudor, the sister of Henry VIII. Mary Rose Tudor was queen in her own right, her husband King Louis XII of France, albeit only for a few months. After Louis's death, she subsequently married Charles Brandon, a courtier brought up in the royal household. His father was standard bearer to Mary's father Henry VII. Charles Brandon and Mary Rose became the Duke and Duchess of Suffolk.

The Suffolks went on to have four children, two named Henry (one died in infancy), Eleanor and Frances. The latter married Henry Grey, Marquess of Dorset. They, in turn, were to have three daughters, Catherine, Jane and Mary. Jane was born in 1537; her grandmother had died four years earlier. The Duke of Northumberland's son, Lord Guildford Dudley, married Jane Grey; in their hands she was to become a political pawn. With the death of Henry VIII, his sickly son Edward VI ascended the throne, reigning for just six years. On Edward's deathbed, a promise to leave his protestant kingdom to Jane (a protestant) was extracted by her father-in-law, rather than to the legitimate heir, the Catholic Princess Mary, daughter of Katherine of Aragon and half-sister to the dying king.

However, the conspirators failed, Northumberland went to the block on Tower Hill in 1553, and poor Jane, barely seventeen, along with her husband, followed, on 12 February 1554. Lady Jane Grey is buried, along with two other headless queens, Anne Bolyne and Catherine Howard, in the chapel of St Peter Ad Vincula at the Tower of London.

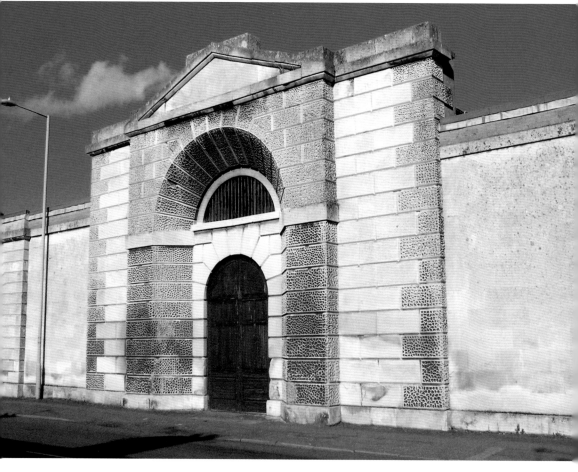

The Last Hangings

The town's most infamous hanging was probably in 1828, and was that of William Corder, murderer of Maria Marten at the Red Barn – one of the most reported crimes ever. The last man hanged at the Sicklesmere Road Gaol was George Carnt, in 1851.

Carnt had been to a public house in Lawshall with his lover, Elizabeth Bainbridge, a married woman. They went outside, Carnt returned alone, his boots and trousers muddied. When asked where Lizzie was, he said they had argued and she had gone home. However, her body was found in a ditch and Carnt was arrested. Various reasons have been put forward as to why he killed her, including a joint suicide pact that went wrong.

The last woman to suffer at the end of a noose in Bury was Catherine Foster in 1847. Brought up in Acton, near Sudbury, she married her childhood sweetheart John Foster, as she said later 'to please mother'. Shortly after marrying, she visited Bury St Edmunds, her first time travelling afar. Realizing there was more to life than Acton, she plotted her husband's demise. She bought some arsenic – poisons were more accessible then – and laced John's supper of dumplings. Poor John was soon in horrible pain, a doctor was summoned who ineptly made the wrong diagnosis. Catherine would have got away with it had the neighbour's chickens not been fed the residual dumplings, promptly keeling over. A subsequent autopsy on John discovered the arsenic – a definite case of 'fowl play'!

Had the eighteen-year-old Catherine committed this heinous crime a hundred years earlier, she would have been burnt at the stake, for to murder your husband then was petty treason!

Bury Gaol

John Orridge was the designer for this 'modern place of incarceration' he already had experience of the then town jail at Moyses Hall. The new gaol opened in Sicklesmere Road in 1805, but the architect who actually pulled it all together was George Byfield. His name is set on the stone string course of the façade's central raised gatehouse, made of stone blocks with vermiculated rustication (worm casts).

George Byfield (1756–1813), a pupil of noted architect Sir Robert Taylor, who was responsible for the Bank of England, gradually acquired a reputation for works in the public sector, as well as commissions for the landed gentry.

Byfield did work on Hurlingham House (Fulham) for a John Ellis, where Bury-born distinguished landscape gardener Humphrey Repton advised on the gardens. Other works include Bassingborne Hall for Sir Peter Parker, and Papworth Hall. He was also estate surveyor to the dean and chapter of Westminster Abbey. Byfield put into practice Orridge's layout for the gaol, which is based on Jeremy Bentham's 'Panopticon' concept, where a central building with radiating cell blocks enabled maximum surveillance of prisoners with a minimum of staff. The Empress of Russia is supposed to have enquired about the layout of Bury Gaol!

Also here at Bury were exercise yards in between the wings, and usage of a treadmill supplied by the enlightened governor John Orridge. Because of him, the prisoner's daily routine was less boring, although rations were still small: 1lb of cheese and one and half loaves of bread per week. Orridge died in office in 1844, aged seventy-one, in the governor's house (now the Fort). The gaol closed down in 1880. Properties were built at the rear of the imposing façade in the 1980s.

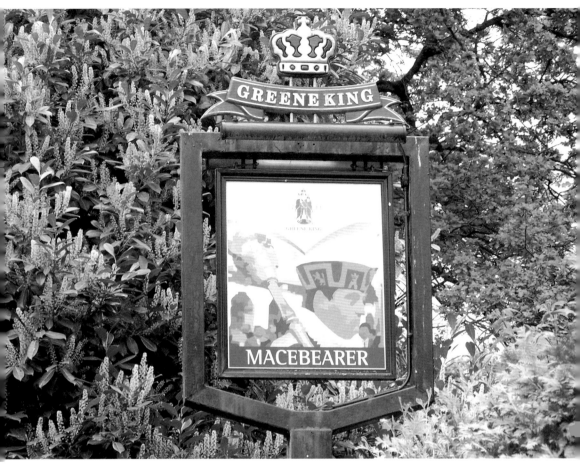

The Macebearer

A pair of cottages with candy twist chimneys were demolished to make way for the Macebearer, and a shopping precinct, on the Nowton Estate. This estate, part of the London overspill initiative was reached via the newly opened Cullum Road and Hardwick Lane.

Architects of The Macebearer were Sandon & Harding of Ipswich, as were the quantity surveyors L N Hyams. The main contractors, O. Seaman & Son, were from Stowmarket, and the total cost of the build was £45,000.

A naming competition for the pub, run by the *Bury Free Press*, was won by Mrs Shirley Pattle of Bury St Edmunds, her winning entry of the Macebearer reflecting the loss of Bury St Edmunds as the capital of West Suffolk, and the street names of borough councillors on the nearby estate.

Judges of the competition were Greene King managing director Sir Hugh Greene, BFP deputy editor Martin Price, and former headmaster of the BSE Grammar School, mayor Robert Elliot. The original pub sign was painted by a Mr Crossley from Rougham Green.

The pub opened on 28 June 1974, with Bob Elliot pulling the inaugural pint with the first landlords Christine and Alan (Mitch) Mitchell. When opened, the canteen-look public bar, with its Formica top tables, was on the left as you walked in by a Jug & Bottle. The saloon bar on the right had a carpeted floor, in complete contrast to the tiled floor of the public bar. Darts, pool and crib nights were popular alongside a very successful winning quiz team. Over the years, many alterations have taken place, an open plan and emphasis on food now being the order of the day. With the closure of several pubs by GK in recent years, the future of the Macebearer, celebrating forty years in 2014, is in the balance.

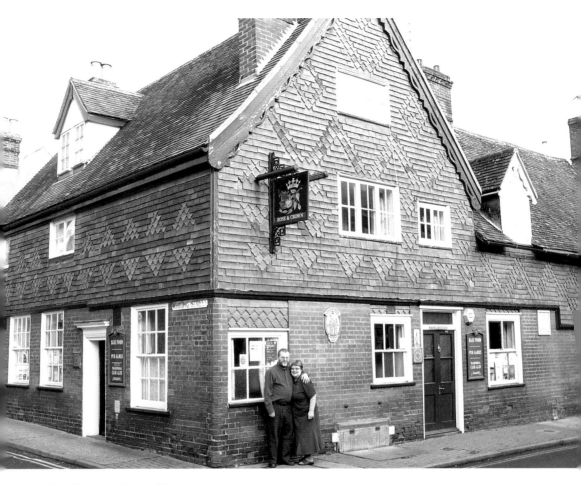

The Rose & Crown PH

Once common in many public houses, the jug and bottle bar, or off sales, has virtually disappeared in Bury St Edmunds. At one time, most drinking establishments used to offer a take home service. This was when someone would bring in a jug or similar receptacle and ask for it to be filled with draught beer. The landlord or a bar staff member would fill it either in pints or to the nearest half pint, and then the customer might purchase a bottle of beer to take away for consumption with his jug of beer.

To provide the ingredients for a dark 'eno', draught mild and a bottle of brown ale were bought; a light 'eno' being a bottle of light ale and bitter. The 'eno' supposedly came from a tale told by a pub regular, that when asked by a drinking acquaintance what he wanted to drink, the man would turn and say 'he know', meaning the landlord would give him his regular tipple!

The Rose and Crown, a Greene King PH, on the corner of Whiting Street and Westgate Street, was sold as beerhouse with cottages on 22 January 1863, receiving its full licence in 1939. On a wall at the rear is a plaque with the initials E.G., for Edward Greene, with a date partly obliterated, reading '18**'. This traditional pub, with a sign of the Tudor Rose, has the only remaining jug and bottle in the town.

Tony and Liz Fayers, currently Greene King's longest serving landlords in Bury St Edmunds, celebrated a family connection of forty years in April 2014. John Ward, Lizzie's father being landlord in 1974, was in 1974, having moved from the Old Angel in College Street that had just closed.

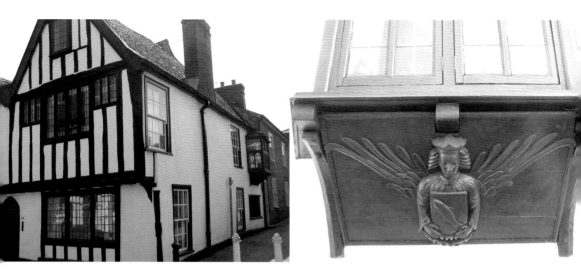

Does An Angel Fly?

Well this one can't, as following the laws of aerodynamics, his wings are upside down. You can find this particular angel in College Lane (Hogg Lane), on the underside of an oriel window. The window belongs to No. 63 Whiting Street, which went through much restoration in the 1960s and was installed by Ernie Warren, a local builder. It is thought the angel came from a church somewhere in the area.

No. 63, and its neighbours, Nos 62 and 61, was a medieval hall house from the fifteenth century. A hall house had a main reception room with an open hearth; the smoke from the fire rose upwards to a high ceiling dispersing via a vent, with chimneys coming later. Typically jettied, the exposed timbers showed off the wealth of the occupant, as good quality timber was very expensive. Fortunately, this exceptional property was not transformed in the Georgian style, as with many of the timber-framed houses in the town. Most of these are on the southern side of the town, as the great fire of Bury in 1608 did not reach here.

The angel is the Archangel Raphael, who is normally is depicted as a young man holding a fish. He is mentioned in the Apocrypha, which is sometimes found between the Old and New Testaments – essentially a compilation of stories about religious figures that were not included in the bible. In the book of Tobit, or Tobias, Raphael instructs Tobias to catch a fish so that he could use part of it to heal Tobias's eyes. Raphael is venerated and associated with healing.

People who look at the angel say that there is no way he can fly, but I've never seen an angel, let alone one flying, so who is to say otherwise.

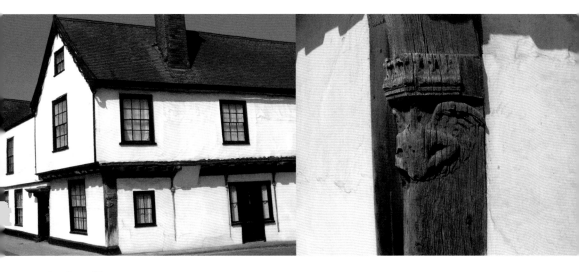

Ancient House

Ancient House, No. 33 Eastgate Street, on the corner of Barn Lane, is a medieval house, once possibly a Guildhall and the home of Bury Grammar School from 1550, founded by Edward VI. The school escaped the ravages of the great fire of Bury in 1608, which started nearby in Randalls the Malsters. In 1665, the school moved to Northgate Street, now known as St Michael's Close. From here it went to its Vinefields site, in 1883. The grammar school's first high master was a John King, albeit for only two years. Once known as foundation scholars, from the beginning of the nineteenth century onwards, Bury St Edmunds boys were called Royalists. Those from outside the town were called 'Foreigners'. The school gradually acquired a great antiquarian library, which was eventually given to Cambridge University in 1971. A year later, the grammar school merged with the two Silver Jubilee schools in Grove Road, as part of the school comprehensive system.

Dating from the fifteenth century, Ancient House is grade II listed, with a timber-framed core that was refronted and rendered, probably in the eighteenth century. It is jettied and has a wonderful carved corner post, supposedly depicting the angel St Michael – only this one has the wings on correctly!

During Victorian times, John Ridley lived at the Ancient House, also running a tannery at No. 62 Northgate Street, later becoming Ridley & Hoopers, although they also registered as tanners at No. 33 Eastgate Street in 1890. When building works were carried out at the rear, during the twentieth century, countless small pieces of leather were found, remnants of the past. It would seem the tannery stretched out down Barn Lane.

Nowton Court

When Orbell Oakes, eldest son of Bury banker James Oakes, purchased Nowton Cottage from farmer John Drinkmill in 1802, he probably had no idea it was to grow into the large country house it is today, as much as he would liked it to be. Not quite as munificent as his father, his ambition to be a landed country gent. To these ends, in 1932, three years after the death of his father, he purchased the Manor of Nowton from the Marquess of Bristol, for the enormous sum of £10,000. He was to enjoy all this only for another five years, as he died aged sixty-nine. His son, Henry James, also involved with the family banking business, immediately started to enlarge the house. He employed a thirty-five-year-old architect from Leytonstone, named George Russell French. Finally, it was left to Henry's son, James Henry, to remodel the property further in the 1880s, eventually removing the remnants of Nowton Cottage that had been incorporated in French's build.

Those were the days of 'upstairs and downstairs', when everyone knew their place. The Oakes family were addressed as Master and Mistress, Sir or Madam, the children young master or young mistress. They were never to be spoken to informally. In Victorian times, over 1 million people were in service, and with such a large house to maintain it required several servants for all domestic needs, including kitchen staff. On normal days, the cook had to prepare a menu consisting of entrees, and at least three other courses. Wages were poor and hours long. With the coming of the First World War, domestic staff were hard to come by and, as the century progressed, so did the costs of running a large house like Nowton Court.

NOWTON COURT

Preparatory Boarding School for Boys

(Ages: 8 to 14. Numbers: 60-70 : all Boarders)

(Recognised as efficient by the Ministry of Education)

Headmasters :

C. J. W. Blackburne, M.A. (Cantab.*)

N. A. E. Blackburne, M.A. (Cantab.)

* Member of the Incorporated Association
of Preparatory Schools

————

The school stands in a beautiful park 1½ miles from Bury St. Edmunds. The house provides ample classroom and dormitory space and the grounds of 20 acres contain a 6-acre playing field where a special cricket '' square '' has been laid by experts. The rest of the grounds are open to the boys for games of all sorts.

Boys receive a thoroughly sound education and training to prepare them for entry to the Public Schools by means of the Common Entrance or Scholarship examinations. The individual needs of each boy are considered and all work is done with the direct help and supervision of the teaching staff. A good allowance of time is made for Music and Art, and each year the school performs a Shakespeare play which is acted out of doors.

Fees are kept at a very moderate level and are inclusive.

Details and prospectus on application to the Headmasters.

Nowton Court, The School

In 1946, Col. Orbell Oakes decided to rent Nowton Court out as a school. The tenants were Charles and Neville Blackburn, and their sister, Betty. Their father was the dean of Ely Cathedral. Nowton was initially a private school with thirty borders; all boys aged eight to thirteen. The classics, arts and sports figured heavily on the curriculum. Corporal punishment was administered – one Latin teacher used a 'hangman' on the blackboard, too many mistakes saw the noose tighten and the cane ensued! The Blackburns were 'luvvies', supporters of the theatre, and the actor Nigel Havers has quoted them as his best teachers.

When the Blackburns retired in 1979, a former pupil who had become the salaried headmaster, Anthony Desch, took over. He expanded the school admissions to include girls, but when the Oakes family sold the estate, including the school to St Edmundsbury Borough Council in 1984/45, the rent was increased. With competition from other schools, he regrettably closed it in 1989.

St Edmundsbury sold the school and grounds to the Matsuzato Corporation, but retained Nowton Park – a wonderful amenity enjoyed by thousands today.

An amazing refurbishment with sympathetic extensions was undertaken by Hutton Construction from Colchester, with no expense spared.

It was the intention to open a Japanese finishing school here called St Edmundsbury Ladies' College, but a downturn in the yen meant it never realised its ambitions. Keio University, the oldest western style university in Japan, then acquired it. Keio had been experimenting with the digitalisation of ancient books, and a facsimile was produced of the Bury Bible, a wonderful medieval illuminated bible. Unfortunately, Keio also failed to attract any meaningful numbers to the school. It then passed onto Euronite, who have now reconfigured some of the bedrooms into apartments.

Jacqueline Close

The name Jacqueline Close has bitter memories for many people. At the top of Mill Road, two houses nearest to the road are all that is left of this development of thirty. As modern three-storey townhouses, they were very desirable in 1964, although somewhat expensive at £4,250 each. They were built by London firm, Tricord Developments. The site, purchased at auction in 1960, held dark secrets, with chalk mines beneath! These finally came to light in December 1968 when, following weeks of torrential rain, great holes suddenly appeared. The houses had conventional rainwater disposal systems – guttering into downpipes, into soakaways. Normally more than adequate, the chalk below was washed away and houses started collapsing.

Emergency housing in the form of newly-built council houses on the Howard Estate were eventually given to the residents on a temporary basis.

Then the post-mortem began. It turned out that the NHS, who had a hospital laundry nearby, had turned the land down for expansion. Perhaps clues in the surrounding area gave them an inkling that something was not right. Nearby Limekiln Cottages, Chalk Road and clues on old Bury maps, like Bullens limekilns, should have alerted any sharp-eyed surveyor. There were even locals who could remember the mines. Suffice to say, a subterranean survey was carried out by the Chelsea Speleological Society, which found huge caverns underneath; the tunnels covering some 2 acres, 50 feet below the surface. Questions like 'why so deep' and 'surely someone knew' were asked. Well, the chalk has to be contaminant free and someone should have known.

What of the poor owners? A public enquiry of 1976 left them severely out of pocket. Only two owners had subsidence insurance, fortunately for them, they paid out!

Limekilns

Bury St Edmunds sits on a layer of chalk. The process that turns this into calcium oxide (quicklime) requires heat. A kiln needs temperatures between 954–1066 °C for the chemical reaction to take place. The quicklime is then mixed thoroughly with water to give 'slaked' or hydrated lime, which is left to rest for two to three months, depending on what use you have for it. At this stage you have slurry or lime putty. Generally, it is one part of lime putty to three parts of sharp sand to make a mortar mix. Obviously there were always tried and tested secret formulas used by tradesmen over the centuries. For hundreds of years, lime mortar was used in the building trade until the advent of Portland cement, although it is still crucial for lime mortar to be used on buildings where stonework is in place.

To make sure the limestone or chalk was free of impurities, it was dug out of mines, and the top of Mill Road and land to the rear of Quarryman's Cottage off Mount Road were two such areas where these were situated. Thomas Warren's eighteenth-century maps show limekilns extending from Clare Road (Out Westgate) up to Field Lane (today's King's Road). Once a common feature, the limekilns have all but disappeared. Many of these were owned by the Bullen family, although William Warren was probably the last lime-burner in the town at St Andrew's Street South. The tragedy of Jacqueline Close could have been avoided if attention had been paid to the limekiln connexions in that area.

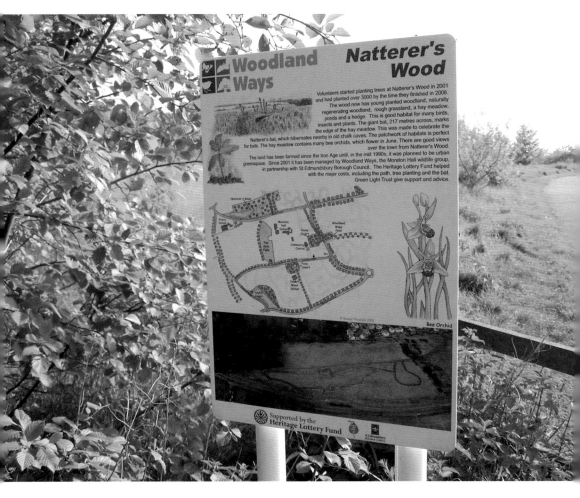

Totally Batty

Bury St Edmunds has its fair share of chalk workings. In the case of Jacqueline Close they were not very welcome. At the top of Eastgate Street, there is a B&B called The Glen, and behind there are bat caves, old chalk workings! Don't expect Robin to appear – he won't – but you might see an appearance of one of the 100 inhabitants under the right circumstances. The tunnels, of up to 200 metres long, branch out of a pit where chalk was once was mined for lime. Five different bat species are regularly recorded here, something that has been going on since 1947. A Daubenton's bat, marked in 1961, was recaptured in 1983, making it twenty-two years old, an incredible age, making it one of the oldest recorded ages for a bat species in Britain. When asked to come up with a name for a local development off Eastgate Street, I put forward Daubentons, due to its close proximity to the Glen. The name was adopted.

Also nearby is Natterers Wood off Mount Road, named for another species of bat that is found in the caves. Here, the volunteers who look after the wood have carved a giant bat into the hillside. The street lighting down Mount Road is especially modified so not to affect the flight path of the bats when they are out hunting.

Clarice House Health Club (formerly Horringer Court), once home of artist Edith Todd, was a residential home for the elderly in recent years. It also has bat caves to the rear in large pits that were chalk workings. The bats are protected by an SSSI (designated Site of Special Scientific Interest), and bars were put over the cave entrances in 1974.

Tunnels Under Bury

We hear so many stories of subterranean passages or tunnels in the town, such as leading from the Angel Hotel or from Waterstone's (old Suffolk Hotel) into the Abbey. It would seem all routes led to the Abbey. Of course there are the multi-tiered cellars of Cupola House, that were linked to others at one time down the Traverse, but, as in common with most of the ancient cellars in the town, those blocked off doorways or arched niches were actually wine bins.

However, three definite tunnels in the town are as follows: One from Buttermarket that was once Debenhams, now JB Sports under Skinner Street to Toni & Guys Hairdressers, in the Traverse, once the household branch of Debenhams. Secondly, across Crown Street from the Greene King brewhouse to their boiler room. A cut and shut tunnel, it was created just before the Second World War, when the new brewhouse was built.

The third is a strange one across the entrance to the churchyard from Honey Hill. William Image, respected surgeon of Honey Hill, had this created in the mid-nineteenth century to enable him to visit in private the other side of his garden that had been bisected by a public right of way. The actual plan for this can be viewed in the Suffolk Record Office.

A blocked off doorway, in the cellar of the former Masonic Lodge in Churchgate Street, reputedly leads to a tunnel in Athenaeum Lane, towards the Angel Hotel, but as in all of these cases access is the biggest problem.

Of course, the town has its fair share of chalk workings, shown is an entrance to one of them.

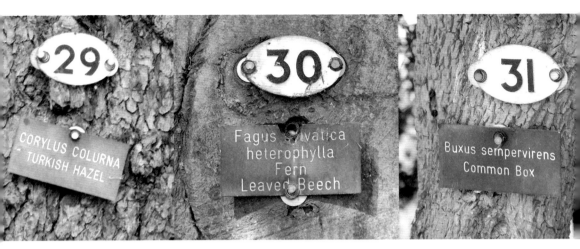

Abbey Garden Discs

The creator and curator of the abbey gardens was Nathaniel Shirley Harness Hodson. Now there's a name to conjure with! After he resigned from his job at the War Office, he came to Bury St Edmunds in 1820, and started a small botanical garden by today's Shire Hall car park, in fact it is now under it. The owner of the Abbey grounds, the Marquess of Bristol was so impressed by Hodson that he asked him to come up with ideas for gardens here.

In 1831, Hodson drew up designs for the new gardens. Based on concentric circles, as in the Royal Botanical Gardens in Brussels, they were to be on the site of the Great Court of the abbey. At first the gardens were not that popular with the townspeople, especially as subscriptions ranged from about two guineas per year for adults and sixpence for children. Gradually they were won over, with small one day entrance fees being charged.

Hodson was meticulous in his record keeping; his catalogue of 1822 had over 2,000 plants listed. Against this background, specimens of trees were identified for the benefit of others by white oval discs fixed to them. At least three can be seen today in the gardens near to the bowling green. No. 29 is an enormous Turkish Hazel, No. 30 is a Fern leafed Beech first recorded in 1820 and finally No. 31, a Common Box. A fellow of the Royal Botanical Society, Hodson was Mayor of Bury in 1855/56, and died in 1861 aged seventy-nine.

The Bury St Edmunds Borough Council purchased the gardens freehold in 1953 from the Marquess. Today, the gardens contribute much towards tourism in the town, including helping it to win numerous floral awards.

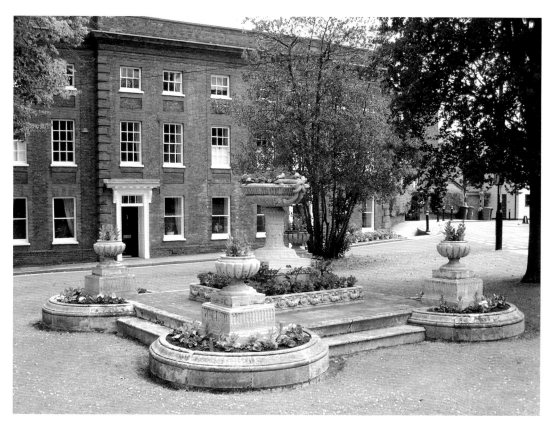

Blanchard Planter

This wonderful planter of 1874 is set on a small green in St Marys Square, which used to be the Horse Market of yesteryear. In need of repair, the planter was restored in 2010, thanks to joint cooperation between St Edmundsbury Council, The Bury Society and The Town Trust. A new stem to the central element of the planter had to be manufactured. Originally, it was designed by Mark H. Blanchard. Consisting of an ornamental terracotta centrepiece with entwining swan necks and four pedestal floral urns, when planted up it looks stunning.

Mark Henry Blanchard served his apprenticeship with the well-established company of Coade and Sealy. Eleanor Coade had perfected a formula for fired clay that could stand up to the harshness of the English winter, frosts and all.

With the Victorian love of classical art forms and the inexpensive method of production, many of these types of garden ornaments became very popular.

In 1839, Blanchard set up his own business in Blackfriars Road, London and, using some of the Coade moulds from the sale of the company in 1843, his work soon became fashionable. So much so that he took a commission from Buckingham Palace after successfully exhibiting at the Great Exhibition of 1851.

Gradually, Blanchard moved away from the lighter colours favoured by the Coade era, a stronger depth of colour being used in his many designs, which ranged from urns to dogs. After all this was an age of sentimentality.

Following the royal patronage, many of the landed gentry opted for Blanchard's garden ornamentation. Today, his works have found renewed fame and are commanding considerable sums of money.

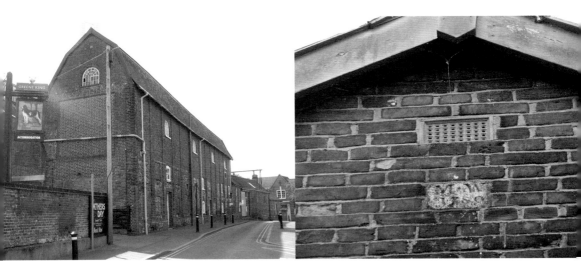

Matthias Wright

High up on the gable wall of the Greene King Brewery Museum, facing the rear of the Dog & Partridge in Bridewell Lane, there are the letters M. W. and a date of 1789. The letters stand for Matthias Wright, whose family had owned a brewery on this site for much of the eighteenth century. In fact, three generations had been involved. The family had made astute marriages to landed gentry in both Norfolk and Suffolk – so much so that they were to become foremost in the activities of Bury St Edmunds. Matthias was involved in the brewing business for thirty years, with his brother Waller and, although Waller was a member of the Bury Corporation for a time, he never achieved Matthias' title of alderman. Not only was Matthias involved in local politics, he found time among his business duties to become a local JP whist living in Barrow.

He died in 1805, during his fourth term in office as alderman. His Westgate brewery had been put on the market in 1798, but after several years there were no bids. After his death, however, an offer was put in by a newly formed business partnership, that of former Bury wool merchant William Buck, and newcomer to Bury, Benjamin Greene, a brewer from Oundle, Northamptonshire. It was accepted by Wright's executors, the year he died.

Buck had been in the wool trade with James Oakes, the 'Mr Bury St Edmunds' of his day, but with the decline of the wool trade, Oakes moved into banking.

On Buck's death in 1819, Benjamin Greene's brewery would eventually become Greene King, one of the largest independent brewers in the country. So, when you see Greene King's Royal Doulton plaques for 1799, remember it is not strictly true.

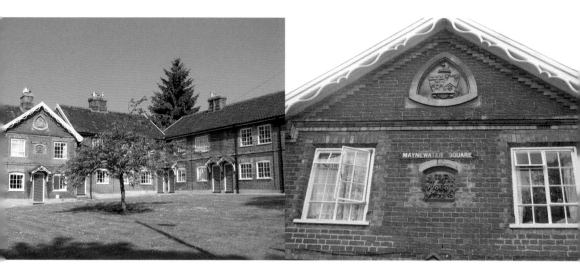

A Progressive Man

In medieval times, the Maynewater Square area was called The Maydewater, a manor curiously belonging to the Honour of Clare. The middle house, in the three-sided square of sixteen cottages, has the Greene family coat of arms with a Latin inscription underneath, *Nil Sine Numine* – nothing without divine will – the *Nil Sine* section nearly worn away. Underneath, another plaque has the date 1868 encircled by sprigs of hops and ears of barley, a reminder of the industry these cottages were built on – brewing. Benjamin Greene's son Edward had taken over his father's business, expanding it during the 1850s. It was during this period of time that he resolved to look after his workers, building a row of cottages in Crown Street in 1859. Six years later, he came out with the dictum 'Every cottage should have at least 3 bedrooms. I will not own a cottage with less for the occupation of families. How can you expect morality among the poor if you put them in hovels only fit for pigs?'

Not only did E. G. (his initials are everywhere on brewery and pub premises) provide accommodation for his workers, he also financed pension schemes for his employees, and in some cases their widows. Edward Greene was a forward thinking man, merging his Westgate Brewery with the St Edmunds Brewery of Fred King in 1887. This is now one of the largest independent brewers in the country, Greene King. Edward Greene, one-time MP for Bury St Edmunds, died in 1891 aged seventy-six.

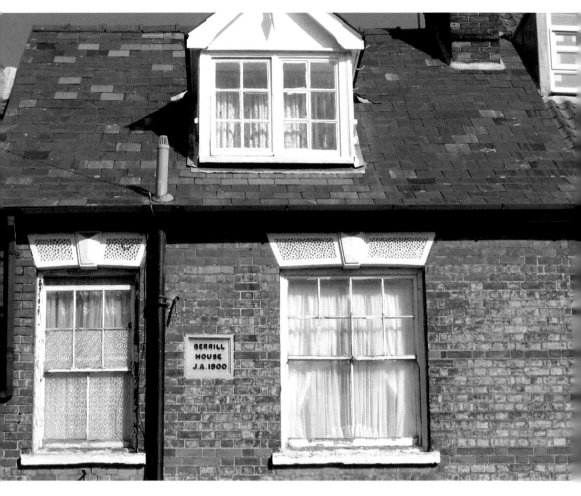

Berrill House

At its number suggests, No. 23a Eastgate Street was built as an infill. Constructed from Suffolk white bricks, with red-brick banding, sash windows and a slate roof, it does not seem out of place in a street made up of several building styles.

There is, however, a plaque on the front that gives a clue to its origins. The plaque says 'Berrill House J. A. 1900'. J. A. was in fact James Alderton, well-known publican of the once adjacent Ram Inn. This inn was one of six that plied their trade in this busy thoroughfare into the town, now there are only two, the Greyhound and the Fox. The Ram was a timber-framed building, adapted later into the Georgian style, with Suffolk white bricks, it can be dated back to the seventeenth century, but most certainly built after the great fire of Bury. This started in nearby Randalls in 1608. When the Ram was demolished in 1971, it had a magnificent white ram sitting on top of its pediment. Unfortunately, it went walkabouts, its whereabouts unknown. Magna House, an ugly office building, was built in its place.

James, who was born in 1833, had been a landlord of the Six Bells Tap on the corner of Athenaeum Lane/Churchgate Street. In 1865, he took over the Ram, a tenancy he held for the next thirty-five years. Now, the story went that our Jimmy boy liked to gamble, whether it was cards, dice or the 'gee gees' is not known, but Berrill House resulted from his winnings!

Ram Meadow a large car park at the rear and also the name of Bury Town FC's ground accessed from Cotton Lane is the only vestige of the Ram.

Three Lasts

The names of Last appear in Bury St Edmunds court records over a span of nearly twenty years, although they were probably not related.

In 1882, a Simon Last was involved with arson at his failing tobacconist shop in Abbeygate Street near the corner of Hatter Street. He was seen leaving the building soon after he had set the fire. Perhaps the most damning evidence against him, however, was that his compensation claim from his insurance company arrived while the fire's embers were still glowing! He was given five years' hard labour for his trouble.

Seven years later, a lesser felonious Last, but nevertheless as exasperating, was up before the magistrates, charged with dereliction of care to his wife and children.

The Lasts lived in Finsbury Square, just off Bridewell Lane. All that is now left is the name on the side of a house. When given one month hard labour by the 'Beak', Freddie turned and said, 'If it was twenty years it would be no worse than twenty years of marriage.'

Perhaps the most inept member of the Last trio was Simon H. Last, not to be confused with the arsonist. A watchmaker by trade, he was found guilty at Thingoe petty sessions in 1901, and given a 40 shilling fine or a month in jail. This Simon had stolen four bushels of bran and chaff from a neighbour out at Bradfield St George. A local constable was called and had no problem in solving the case – he just followed Simon's footprints in the snow back to his house!

At first he denied it, but when the goods were found hidden under sacks, he admitted his guilt.

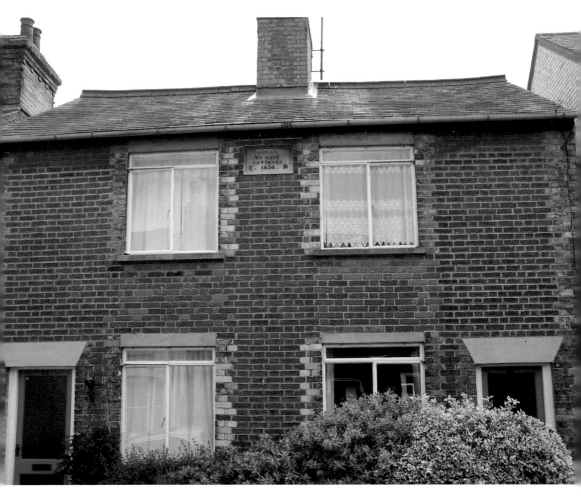

Notice to Quit Cottages

The two houses at Nos 22 and 23 Victoria Street have this very unusual name. They were built in 1874 on land that used to be a market garden, by farmer Charles Nunn, who lived at Sextons Hall, Newmarket Road (then in Westley Parish). Charles and his wife Mary had two daughters. Margaret married, becoming a Mrs Lamb, but Elizabeth did not marry, possibly as she had a child out of wedlock, a taboo in Victorian middle-class England.

Elizabeth's child was called Robert Elliston Charles Wright, the last name being her mother's maiden name. This was quite common in those days, Charles obviously being her father's. However, the first two names are a puzzle – very precise and the second certainly unusual. Around this time, a farmer with this name was living at Thorpe Morieux – could Robert Elliston have been the father?

The stigma of having an illegitimate child was not looked on favourably, but it would seem Elizabeth and young Robert were well looked after. They subsequently lived at No. 2 Cemetery Road (Kings Road), but Elizabeth died in 1889. Charles Nunn died four years later, but his will stipulated that Robert, on reaching twenty-one years of age, would receive £2,000, a handsome sum. An eponymous trust was set up to administer the will's bequests. Were Notice To Quit Cottages just for that – short term rentals to bring a regular income in? If they were, the subsequent tenants rented them with no trouble at all for a good number of years. The Charles Nunn Trust put the two cottages up for sale at Everards Hotel in 1955, when they were sold to a Mr Hughes of No. 28 Victoria Street for £220. He owned them up until his death, before it was sold again in 1976.

Wall Disputes

No. 8 Sparhawk Street, later to become The Chantry Hotel in the twentieth century, was owned at one time by a Susan Smith. She sold it to the De Carle family in 1831. The De Carles were reputable stonemasons, carrying out works for respected local families of the day, including the Bristols of Ickworth. There was a covenant with Thomas De Carle 'not to erect any buildings upon or against walls recently erected by him on the south side'. There may have been some animosity with the De Carles locally, as, only two years earlier in February 1829, a boundary dispute with Henry Crabb Robinson was settled in a most unusual way, with part ownership of the same wall. Two plaques on a rear wall at the Chantry declared, 'The North half of this wall belongs to Thom. De Carle Febr. 1829, 'while on the other side, where the Greene King barrel yard is, it says, 'the South half this wall belongs to H. C. Robinson Febr. 1829.' So clearly there were some arguments who owned what.

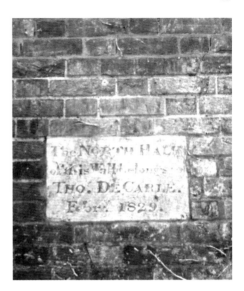

H. C. Robinson lived at No. 32 Southgate Street, the family home, and achieved a reputation as a journalist. He was left inheritance, using it to travel around Europe and got caught up in the Peninsular War involving Napoleon. He sent reports of the conflict back to *The Times*, in effect becoming the first war correspondent. Mind you, it is not uncommon to find plaques resited, so who knows their original positions or meanings. Suffice to say, just over a year later, a plaque, reading, 'This wall is the entire property of Tho. De Carle 11 Sept. 1830.', was on a wall somewhere near. An extension, built by owner Nigel Jackson in 1986, did in fact resite the plaque. Could Thomas have been a neighbour from hell?

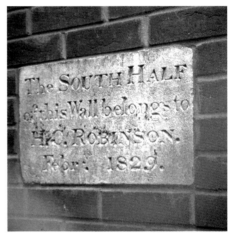

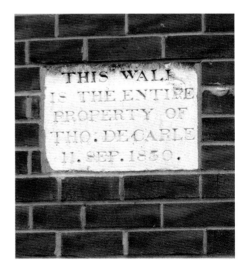

A Royal Lock

Mary Rose Tudor, born in 1496 and sister of Henry VIII, went on to become Queen of France, marrying the aged Louis XII at the tender age of eighteen – according to contemporary accounts she was quite a looker. Louis died just after three months marriage, albeit with a smile on his face.

As a widowed queen, Mary was a valuable asset, and so Henry dispatched Courtier Charles Brandon over to France. Unbeknown to Henry, Mary had her eye on him, the upshot being she married Charles, reminding Henry she married Louis for duty, but married for love this time. Eventually forgiven, the couple, now styled as the Duke and Duchess of Suffolk, lived at Westhorpe, literally holding court in a pavilion when they visited Bury St Edmunds fair. Mary, however, preferred to remind people of her royal status. They had three children survive infancy, but she was dogged by ill health, succumbing to the Tudor curse – the sweating sickness – in 1533.

Her lavish funeral, a huge cortege with French heralds, was the last great event at the abbey church prior to the dissolution in 1539. She was laid to rest in a great alabaster tomb. When that fateful day came, and the abbey despoiled, she was moved soon to a somewhat plainer tomb in St Mary's.

On 6 September 1784, it was decided to lower the height of the tomb, as it got in the way of the communion table. At the same time, her coffin was opened under the watchful eye of Sir John Cullum. She wore 2-foot long tresses, but reports differed to whether they were red or gold. A lock of it was taken and can be seen today in Moyse's Hall Museum – it is golden! Her simple grave is still in St Mary's.

ORONATION **1953** CELEBRATIONS

30th MAY to the 7th JUNE

LONG LIVE THE QUEEN

Borough of Bury St. Edmunds

CORONATION 1937 CELEBRATION

9TH MAY TO THE 14TH MAY.

LONG LIVE THEIR MAJESTIES.

Official
Souvenir Programme

Coronation Celebrations

To celebrate the coronation of King George V in 1911, Cemetery Road was renamed Kings Road in his honour, and flags and buntings were flown in the town. A loyal toast was given by the Corporation on his Coronation Day of 22 June, and the lease on The Abbey Gardens was formulated in his honour.

The 1937 Coronation celebrations of George VI were a far more elaborate affair. A committee, chaired by the Mayor Cllr Robert Olle, was set up to organise sub-committees, which ran the numerous events spread over six days, starting on Sunday 9 May until Friday 14 May; Coronation Day taking place on the Wednesday. Events included a grand boxing tournament, concerts and dances, six-a-side football and dinners. There was even tea with orchestral music in the Athenaeum, for 'old people and the blind'. The Abbey Gardens hosted some of the proceedings – a party for the children with entertainers, ice creams and specially printed bags with cakes and buns in – today's goody bags! The first baby born on Coronation Day received a pram given by the mayor. At the acclamation ceremony, schoolchildren singing 'Land of hope and glory' en mass was a highlight.

For the Coronation of Queen Elizabeth II, in 1953, a tried and tested formula was used by the mayor, who was again Robert Olle. This time, the celebrations ran from Saturday 30 May until Sunday 7 June; the grand event itself on Tuesday 2 June. The usual dinners and dances were held, and a special treat for 'the old people's coronation celebration' – a coach tour of the countryside! Once again, schools and children were much involved.

Various competitions were held like whist drives and a pram race in Eastgate Street. I wonder what current 'old people' can recall of these occasions.

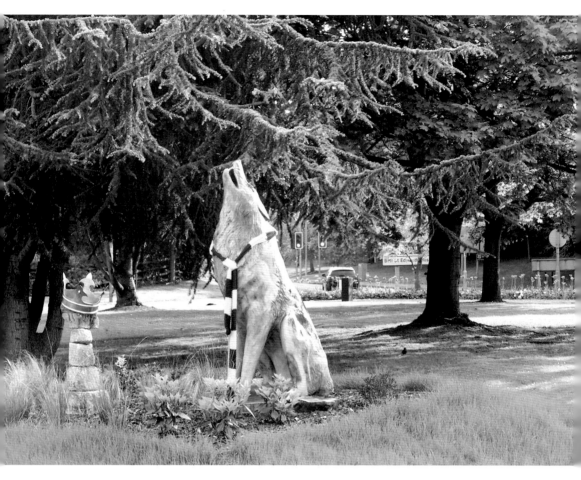

The Wolf

When the Borough Offices on Angel Hill were built in 1937, the consultant architect, Basil Oliver, used a local artist Sybil Andrews to design the stone cartouche on the pediment. Basil, the son of a Sudbury brewer, was one of the last exponents of the Arts and Craft movement. Sybil, the granddaughter of respected ironmonger Fred Andrews, was to go on to become a world famous artist.

On the cartouche, there are the three crowns of the Abbey pierced with arrows, plus two Latin inscriptions which read 'cradle of the law' and 'shrine of a king'. They relate to the town's association with the Magna Carta, and the fact that the martyr, King Edmund, was entombed here. The top of the cartouche has Edmund's head between the paws of a wolf, part of the legend of the king's death, where he was decapitated by the Danes after being shot full with arrows. He had been captured following his defeat at the Battle of Thetford. His thrown-away head was found by a wolf, from which it was recovered by Edmund's followers. Also on this building's entrance doors are two bronze handles; cast in 1936, they have the same image of a wolf guarding the head.

Two more stone carvings of the wolf and head can be seen: one is above the Guildhall entrance porch, including the pierced crowns, and the other is just below a window sill on Moyses Hall Museum. Unfortunately, this is somewhat weathered. Although there are other depictions of the wolf around the town, the latest, a statue of a wolf, carved from a tree trunk on Southgate Green roundabout, is magnificent, put there under the auspices of The Bury Society – 'Wolfy' – now adopted by Bury Rugby Club.

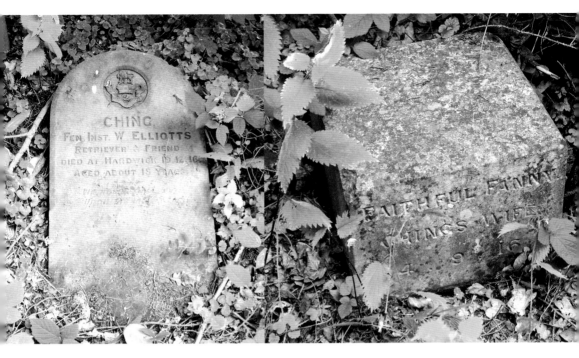

Cullum Pet Graves

Near to the St Nicholas Hospice, at the West Suffolk Hospital, are situated five gravestones. Although the wording has become weathered, some of the inscriptions can still be read:

'Poor old Dandie July 1894, Jeannie mother of many children'; 'Poor blind Peter drowned 23.3.18**'; 'Ching and Faithful Fanny, Ching's wife'. Now overgrown, the area where these are situated was once accessed via elaborate wrought-iron gates, which are still there. Most likely dogs that were owned by the Cullum family, they serve as a poignant reminder of what was once a grand estate. As George Cullum never married some of these pets were constant companions. His death, in 1921 aged sixty-four, precipitated the estate being claimed by the crown, as we have previously seen. The Elizabethan Hardwick House had been enlarged in 1681 and then further altered around 1839. Set in grounds of 352 acres, it had a Home Farm. This name carries on today, with the farm manager's house from 1838 near the end of Home Farm Lane. There was also a pair of thatched cottages for agricultural workers. After the closure of the old West Suffolk Hospital in Hospital Road, a new one opened in 1974 at Hardwick. It was a 'best buy' design, similar to Queen Elizabeth Hospital, Kings Lynn, and The James Paget at Gorleston. Gradually, various annexes and extensions have been added at Hardwick, including the St Nicholas Hospice.

Hardwick Heath, owned by St Edmundsbury Council is an important amenity for the town of Bury St Edmunds, with football pitches and large open spaces for dog walkers. I'm sure the Cullum dogs would have appreciated it too.

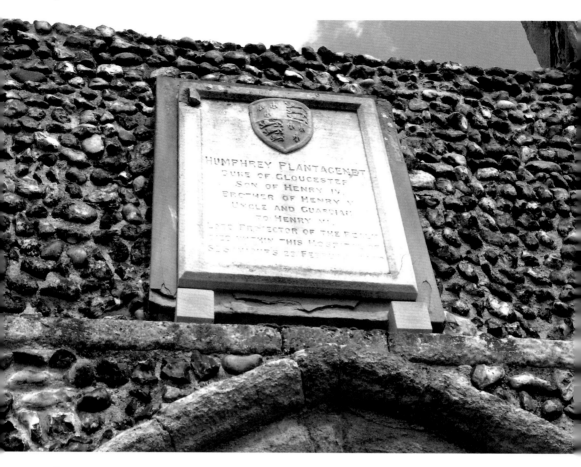

The Missing Plaque

Bury St Edmunds in 1907 saw a wonderful pageant of the town's history.

There was also a concerted effort to celebrate the people that had contributed to Bury's rich heritage by commemorating them with stone plaques.

A year earlier, The London Society of East Anglians put forward a suggestion to do just this. Following up from this, Bury town clerk, Arthur P. Wheeler, sent a letter to the *Bury & Norwich Post*, which was printed on 20 November 1906, detailing four people to be celebrated. It also goes on to say:

> To enable the matter to be more fully considered and an estimate made as to the cost of fixing the necessary tablets, I shall be pleased to receive any suggestions to any house in the Borough which has been so occupied together with such particulars to give in relation thereto.

Subsequent to this, an article appeared on page three of the *Bury & Norwich Post* of 3 February 1907; it had a list of sixteen people, including short biographies about them, put forward to receive a plaque.

Of these sixteen suggestions, twelve were taken up. How they were selected or by whom is not known. Coinciding with the pageant, the chosen dozen were put up. It has always puzzled me why there are eleven of these oval stone plaques in the town – you can still see them all. Where was the twelfth, has it disappeared? I found out it wasn't oval at all! The 'missing plaque' was rectangular in shape, honouring Humphrey Plantagenet; it is on the former medieval hospital of St Saviours, in Fornham Road, paid for by George Milner Gibson Cullum.

Masonic Symbolisms

As a recorder of stone inscriptions, when this particular one was brought to my attention I didn't understand what its underlying meaning was. The tablet is tucked away on a wall at the rear of Bath Cottage, Maynewater Lane. This house was built by the L. J. on the plaque, Lot Jackaman, in 1870; however the plaque has 1868 on it. Lot had built swimming baths at the rear that are no longer there; he installed them after supposedly getting the idea from Germany. Lot's tour de force in the town was the Corn Exchange in 1861/62. An interesting story concerning Lot's quote for the work concerned the glass roof. He is supposed to have signed it off 'all in', meaning a fixed quote with no extras. However, on completion, Lot's surveyor added the cost of the roof on the invoice to the corporation, as Lot had not included it on his quote. He was not paid for it because a sharp-eyed corporation accountant spotted the 'add on', and reminded Lot of his 'all in' clause – ouch!

Anyway, back to the Masonic device. If both arms of the dividers are in front of the square, it denotes that the mason was a master mason. If one arm was in front and one behind then the mason was of the second degree, or fellowcraft. If both arms were behind then the mason was an entered apprentice. These relate to when stonemasons were actively working with stone and showed their capabilities. Lot Jackaman was a second-degree mason according to this plaque; however, there is no record of him being a member of any Bury Masonic Lodge. Nevertheless, he was a first-class builder!

On Yer Bike

Lord Tebbit, who now lives in Bury, uttered the words 'on yer bike' in 1981, to encourage people to look for work.

Once a mode of transport for the lesser well-off, cycling is now looked on as also a way of keeping fit. Cycling has seen a major resurgence in the last thirty years, with dedicated cycle routes, shared space on footpaths and bike racks in designated areas. This year, 2014, saw a major cycle flyover, The Malthouse Bridge, built over the A14, and the first Women's Tour of Britain bike race finishing in Bury St Edmunds.

James Moore, born in the Bury St Edmunds Brackland in 1849, was the winner of the first ever bicycle race in the world, at St Cloud in Paris when aged nineteen. A year later, he won the world's first road race from Paris to Rouen, a gruelling 81 miles! He lived most of his life in France, but died in England in 1935 aged eighty-six.

Around this time there were fourteen cycle dealers in Bury, reflecting the popularity of bicycles, such as Townsends, Henleys, Scotts and Halfords.

Dear old Charlie Allan, whose cycle shop was in Eastgate Street, left a wonderful bike collection to Moyses Hall Museum, a contemporary of Charlie was my father, a dab hand at doing up bikes, cannibalising three wrecks to make one decent one. During the Second World War, my older brother would sell them at the American air base at Rougham, where they were highly prized and known as ASPs – all spare parts! John Appleby, an American airman who left his *Suffolk Summer* book royalties to create a rose garden in the Abbey Gardens, rode around the countryside on a 'Green Hornet'. West Suffolk Wheelers, formed in 1922, is still going strong as is a major fundraiser for local charity St Edmunds Wheel Trust founded in 1998.

On the Buses

Charabancs were the forerunner of the coach. In the 1920s, these open-topped motorised vehicles were popular for excursions and the like. Gradually, coach companies emerged such as Corona, Fulchers in Whiting Street, Barchams and Mulleys – the latter owned by philanthropic Edward Mulley, better known as 'Jack'. Once known as Mulleys Motorways, their distinctive orange and cream livery is still about today, the present owners acquiring Mulleys Coaches in 1980. In 1947, The Eastern Counties Omnibus Co. opened a bus station in Brentgovel Street, then a major route through the town. Access to it required great driving skills; eventually Looms Lane was widened, but the situation was not improved until the Bury bypass opened in 1973. Their bright, red buses were once serviced at their Cotton Lane depot, the site now awaiting redevelopment.

How many people can remember the idling diesel engines, while checking the timetable and looking at the station's clock to see if they were on time? The clock is still there, on the wall of Hair, His & Hers, carefully looked after by the salon's owners, Jenny and John Parkington, who inherited it. The bus station lingered on until 1987 and a McDonalds is there now.

A modern bus station in St Andrew's Street North was built in 1996 costing £1.2 million, although visiting coaches still drop off passengers on Angel Hill, just as they did at one time outside Moyses Hall. Nowadays, parking for coaches is available at Ram Meadow and Rougham Hill.

For a while, the town operated a shuttle service with smaller buses called Hoppers, but somehow it never succeeded. Today, town bus services still run daily.

ANNUAL
MAGNA CARTA STAKES

OPEN RACE
FOR 18 DOGS

RUN OVER 510 YARDS IN 3 HEATS
FIRST TWO IN EACH HEAT INTO FINAL

Winner £200 and Trophy
Second a Trophy

3rd & 4th TO CONSOLATION FINAL
(WINNER £50)
ENTRY FEE £10 EACH DOG
ENTRIES CLOSE JUNE 19th
HEATS TO BE RUN JUNE 24th — FINALS JULY 1st

CONDITIONS OF OPEN RACE TO BE HELD ON JULY 1st, 1965

1. The draw will be made in public at the Club House after Racing on Saturday evening, June 19th.
2. All dogs to be kennelled by 7 p.m.
3. Heats will be run on Thursday, June 24th meeting, commencing 7 p.m. The Final on Thursday, July 1st meeting, commencing 7 p.m. The first two dogs in each heat will pass through to the final. 3rd and 4th dogs to run in consolation final.
4. Entry Fee to be the sum of £10 each dog and the prizes will be £200 for the first dog, a Trophy for the second and £50 for the consolation final winner.
5. Entry forms must be completed and handed in with entry fee accompanying same by June 19th.
6. The decision of the Management of the West Suffolk Greyhound Stadium will be final and binding in all matters.
7. All dogs run at owner's risk.
8. The entry fee must accompany entry form. No dog accepted until entry fee is paid.

ENTRY FORM

I wish to enter my dog................................ colour...................
sex............ for the Open race to be held on July 1st, 1965 at the West Suffolk Greyhound Stadium. I enclose entry fee £10 herewith.
I agree to the conditions as set out above.

Name...
Address ..
..

Winning Traps to Date

Trap No.	1	2	3	4	5	6
Wins 1964	147	142	118½	126½	152½	160½
Wins 1965	61	35½	39½	32	42	59

Greyhounds

The West Suffolk Greyhound Stadium opened in Bury on Thursday 1 December 1949. The Dutton family, especially 'Joby', and latterly Duggie Dutton, were instrumental in this venture. On that day the entrance fee was two shillings and threepence, the race card sixpence. In 1965, the biggest prize money on offer was £200, with £50 for the runner-up, but, by 1984, it had risen to £1,000 for the winner. Most races were run over 300 hundred or 510 yards and occasionally there were hurdle races. Local bookmakers attended, such as 'Chopper' Leech of St Andrew's Street North, and some even sponsored races by giving the trophies. Some bookies, like the greyhounds themselves, came from far afield. Time trials took place, so that on race night the greyhounds could be allocated the correct graded race.

Although not registered or regulated by the National Greyhound Racing Association, it nevertheless was still well run. For many years, the racing manager was Michael Steed and the starter and groundsman was 'Dinky' Brame. It was not uncommon to have 600 people attend race nights, which were on Thursday and Saturday nights, although 250–300 was the norm. Racing started at 7 p.m., with the last race finishing at 9.15 p.m. For many regulars it was also a social event. The track closed on 25 June 1996, with many people sad to see it go. The stadium off Spring Lane, along with the Percy Fulcher Steelyard and Spring Lane Caravan Park, was supposed to be part of the inner relief road of Bury St Edmunds, but this was never preceded with, and Bloor Homes built an estate known as Tayfen Meadows.

The Grindle

This area of Bury St Edmunds is just off Beech Rise/Southgate Street. There are different theories as to why it was called The Grindle. The fine cartographer of Bury, Thomas Warren, shows on his map of 1747 the Grindle linking from near the South Gate through to York Bridge and Friar's Lane. Could this have been part of the town's medieval defences protecting the Southgate suburb? After all, a mound that once formed part of the Grindle would have made a good fortified position. Was it possible that Grindle derived its name from the word Grinn meaning fortress? According to the *Oxford Dictionary of Place Names*, Grindle also means, green hill. The antiquarian, Edmund Gillingwater, in his 1804 book *An Historical Descriptive Account of the Ancient Town of St Edmundsbury*, has it as a 'place of security for cattle and other necessaries'. This was in the days when Bury was thought to have its origins as the site of a Roman settlement, the *Villa Faustini*. We now know this is not the case. Apart from a few shards of pottery thought to be Roman, found in the building of the residential home No. 11 Cullum Road, and a small development at Plumptons Yard, St Andrew's Street South, there is no evidence of Roman occupation in Bury.

In 1962, an archaeological dig was carried out by volunteers at the Grindle under the guidance of Moyses Hall. Nothing was found, disproving the ancient theories. Housing was built soon after, appropriately known as Grindle Gardens. An area known as Grindle Paddocks is set aside as a nature reserve, a leftover from Redrow Homes nearby, off Southgate Street. The Paddocks have watercourses running through it, straddled by York Bridge; some of the more diverse inhabitants are crested newts and water voles.

Babwell Friary

Francis of Assisi established the Franciscan order of Friars in 1210 – the Friars lived under monastic vows but went into the community to work and preach.

The Franciscans came to Bury St Edmunds in 1238, settling in what we know today as Friars Lane. The abbot of St Edmundsbury Abbey objected to these potential rivals and twice removed them. Finally, in 1262, with the help of Gilbert De Clare, the friars settled at Babwell Fen which was outside the jurisdiction of the abbey. The townspeople supported the friars, even leaving bequests to them in opposition to the abbey. In 1327, there were bitter riots in the town against the abbey's taxes and controlling influence. A merchant, John de Berton, was elected as alderman, and along with a Gilbert Barbour and a mob, attacked the Abbeygate, destroying it via The Cook Row (today's Abbeygate Street). Subsequently, they were captured and imprisoned in Norwich, escaping to seek sanctuary in Babwell Friary. On leaving the friary, they kidnapped Abbot de Draughton of Bury Abbey who was freed two years later. Ultimately, both were arrested, with Berton to die in prison.

The friary was closed in 1538 by Henry VIII; a private house was then built on the site by the Boldero family. The Cullum family owned it from the late eighteenth century until the breakup of the Cullum Estate in the 1920s. Later, Alderman Olle lived here until it was sold to become the Priory Hotel in 1975.

In 1990, an archaeological dig for owner Edward Cobbold's extensions to the hotel, uncovered foundations of the friary church, along with twenty-three burials. One with a chalice and paten was found, possibly belonging to Robert Windell, once Suffragan (assistant) Bishop of Norwich in 1424. He died in 1441, with his will of 1411 requested to be buried at Babwell.

The Butts

The Abbey owned Almoners Farm Barns Estate was near here.

Since medieval times, when longbow practice was compulsory, part of this wetlands area of the town near the Westgate was also known as The Butts. This refers to the target that an archer fired at. Once a national sport, archery won the battle of Agincourt.

The Westgate, pulled down in July 1765, stood where today the double mini roundabout is, a traffic conundrum if ever there was!

Also here was the dubiously named Hellfire Cottages, along with Butts Place. An apocryphal story about how Hellfire Corner came to be dubbed as such was that the future vicar of St Peter's church, before it was consecrated in 1858, used to hold open-air services in the nearby water meadows, preaching 'hellfire and damnation' to those who didn't repent. The water meadows were reached via a small lane called Cullum Road, which finished at what is today Corsbie Close, built on the former Atlas Engineering Works site. A relief road linking southern Bury was created in 1972, with Cullum Road no longer a small lane. The Cullum family owned Hardwick, their name cropping up time and time again. In creating the Parkway, at the rear of St Peter's church in 1977, a Victorian rubbish dump was uncovered, with bottle and pot lid collectors descending in their droves.

Criss-crossed by small trackways, footpaths, ditches and riverlets, the boundary of the water meadow is the river Linnet, which rises in Ickworth Park. Close to the Linnet are Holywater Meadows and a nearby close called Holywell. This has nothing to do with religion, but a spring once called The Holewell. Just a few minutes away from the town centre, the Butts has countryside feel to it.

The Grapes Inn

At the crossroads of Brentgovel Street, St Andrews Street and Risbygate Street is the Grapes Inn, once the site of the Risbygate. In medieval times, a stone chantry chapel stood close by. As with the other four town gates, it was taken down in the mid-1760s to allow for better access to the town.

The Grapes Inn has an archway that once led to stables; on the arch keystone are the letters J. B. and the date of 1837. Joseph Baker was the landlord of the Cock Inn that stood on the site of the chapel. When part of the Cock was demolished to make way for the current building, he continued in that role until 1840 when George Chinnery became landlord. Chinnery oversaw the changeover name to the Grapes Inn around 1848. At this time the Inn had been in the ownership of Henry Braddock, who had the Southgate Brewery.

There is now nothing left of the Southgate Brewery, which was on the corner of Southgate Street and Maynewater Lane. In 1868, Henry Braddock died, and his brewery and portfolio of eleven public houses, including the Grapes, was purchased by Edward Greene for £7,000. Greene immediately demolished the brewery to stop it falling into the hands of Fred King, a malster who was looking for brewing premises. As it so happens, Greene King were formed by the amalgamation of these two men in 1887.

Some internal changes were made to the Grapes in 1926 and 1976. One of the few establishments in the town to have live music, it still is a favourite watering hole for many.

Niches and Icons

One of the most common images to promote Bury St Edmunds is the iconic Abbeygate. However, its predecessor, similar in style to the Norman Tower, was destroyed by rioting in 1327. As the secular or townsfolk entrance it was rebuilt by 1347 in the English Decorated style.

Adorned with niches on the front, and some on the rear, these probably contained statues to various saints but were removed after the reformation when Henry VIII broke with Rome.

That fine academic, Montague Rhodes James, was brought up locally, his father being the rector of Great Livermere church. He put forward a very bold theory in his book *Suffolk and Norfolk* about the front of the Abbey Gate. Immediately over the entrance gates or portcullis are three niches, the central niche slightly higher than the other two. Though pure conjecture on his part, he said 'they may have contained St Edmund and two archers'.

M. R. James was a respected antiquarian and historian, who at one time was the Dean of Kings College, Cambridge and Eton College. His seminal work, *On the Abbey of S. Edmund at Bury*, is much respected. It was he who discovered the whereabouts of five of the abbot's graves in the Chapter House, Bury St Edmunds, while researching in Douai in France.

Could that central niche really have contained the arrow pierced statue of St Edmund, while being flanked by his two Danish slayers? Or was Monty exercising his vivid imagination as he has done so much in his celebrated ghost stories? After all, there is not another account of his hypothesis anywhere else ... or is there?

Brandon Rubble

After the dissolution of St Edmundsbury Abbey in 1539, the site became a builder's merchants for the people of the town, the limestone a valuable resource for properties. It is said that you will find the abbey stone all over the town, but not any further than 6 miles outside it – the distance covered by a cart and oxen there and back in a day. The greatest re-use of this stone is in a wall by the Farmers Club in Pump Lane, measuring approximately 100 ft long by nearly 6 ft high! This wall is not made up of odd pieces, but actual blocks.

One thing that is noticeable as you walk around the 'historic core' of Bury is walls consisting of pieces of brick, limestone and flint. I once asked a builder friend of mine, 'John, what do you call that type of wall construction?' He replied 'Brandon rubble.' I assumed Brandon rubble because of the high flint content. Brandon a town 15 miles to the north of Bury, famous for flint knapping, a skill that was still in use to provide flints for muskets up till only a few years ago.

Now, when I started as a tour guide several years ago, I would tell the punters of the usage of the Brandon rubble. However, on about the fifth tour I did, my wife was with some friends I was taking round the town. On relating the story of Brandon rubble to these friends, she pulled me to one side and said, 'What did you call that type of wall?' I replied what my mate John had told me, Brandon rubble. 'No he didn't cloth ears, he called it RANDOM RUBBLE.' Now that's a true story.

Abbey Ruins

St Edmundsbury was once one of the greatest abbeys in the country, on a site of several acres; all that is left now is a mere glimpse of its magnificent Abbey Church. This was 12 bays long, 515 feet long and, at the widest, the west front 246 feet across. Of its main two towers, we can only speculate the height.

Building started at the east end in 1080 by Abbot Baldwin, and was finished around 1210, although several catastrophes such as fires and towers collapsing happened at different times. At the shrine of St Edmund, once a patron saint of England, attention was given by between sixty and eighty Benedictine monks. They were helped by lay-brothers, a term that for many years was thought to be the origin of labourer. The town of Bury St Edmunds owed its very existence to Edmund.

The construction of the abbey's buildings consisted of limestone blocks, mostly obtained from Barnack on the Northamptonshire border. As the walls progressed, a core mixture of flint and lime mortar was then poured in, which gradually worked its way upwards with the limestone, with both components of this core readily accessible beneath your feet.

All that remains today is that core stripped of the limestone casing, soon after the dissolution in 1539. If the town's people ever wanted revenge for the rule of the abbey, now was the time to do it.

To quote from the poem 'Ozymandias' by Shelley, 'Look on my works, ye mighty and despair, nothing beside remains'. Some people may look at the ruins now and see something completely different. To the keen eye looking southwards, two shapes appear, on the left a cockerel complete with an eye, on the right a kettle. Trivial but fun nevertheless.

The Demon Frieze

No. 59 Abbeygate Street, now a Café Rouge restaurant, was built in 1891 to designs by John Shewell Corder of Tower Street, Ipswich, for The Sun Alliance Assurance Co. Ltd. The Alliance Assurance Co. was founded in 1824. This date is up high on two castles that look very much like two Gibraltar castles, as on the Corn Exchange opposite.

Corder was born in 1856 in South Shields and educated in York. His father became a silk merchant of Tavern Street, Ipswich.

Our John became articled to Joseph Morris of Reading from 1872 until 1877, as Morris' younger sister, Maria, was Corder's stepmother. Well, we know that much about him, but we don't know what drove him to design this neo-Jacobean edifice and its extremely strange frieze.

The bottom section of the building is red sandstone with red-brick above, but it is the rubbed terracotta frieze, in between on either side of the entrance door, that sets it apart from any other building in Bury St Edmunds. Sure enough, there are the usual swags and tassels you associate with any carved decoration. There is even respect for the history of the town itself, with the borough insignia of three pierced crowns, but it's the other components that are puzzling.

As each frieze is identical, everything is repeated; there are serpents, dragons and griffins and a demonic face. Why?

Corder eventually became a well-respected architect, being consulted on many restorations and even writing a book on Christchurch Mansion.

He was also employed by Tollemache Cobbold to carry out work at the Griffin Hotel in Bury St Edmunds. His portico with griffins on was unfortunately nowhere near the quality of the Alliance property. John died in 1922.

Salem Place

We associate the name Salem with witches; perhaps the most infamous witch trials of all were held at Salem in colonial Massachusetts between February 1692 and May 1693. Then, over 200 people were accused of witchcraft, brought about by what we know today as mass hysteria, with twenty people put to death. This is why the name Salem is now vilified, somewhat strange considering it is a shortened version of Jerusalem.

In Bury St Edmunds, we too had our fair share of witch trials. The so-called 'Witchfinder General', Matthew Hopkins from Manningtree, plied his trade in the town, receiving 20d for putting at least 200 people on trial. Of these, eighteen were put to death in August 1645. His favourite way of finding a witch was to 'swim' the poor wretched soul, tying their thumbs to their big toes and immersing them in water. Those who swam were guilty, catch 22! Eventually he was exposed as a charlatan and disappeared, dying in 1647.

In 1664, Bury was the scene for another witch trial – that of two Lowestoft widows, Amy Duny and Rose Cullender. Both were executed on the most trivial and flimsy evidence. Eventually the Witchcraft Act, brought in by James I, was abolished in 1736.

A Benjamin Cook lived at Salem Cottage near to Salem Place, a small Victorian terrace in today's Kings Road. Benjamin Cook was the father-in-law of Thomas Ridley, a grocer and ardent Baptist. Whether Thomas had any problems with the name Salem is unknown, but in 1880 he had extended the house frontage, becoming No. 64 Cemetery Road, Linden House today.

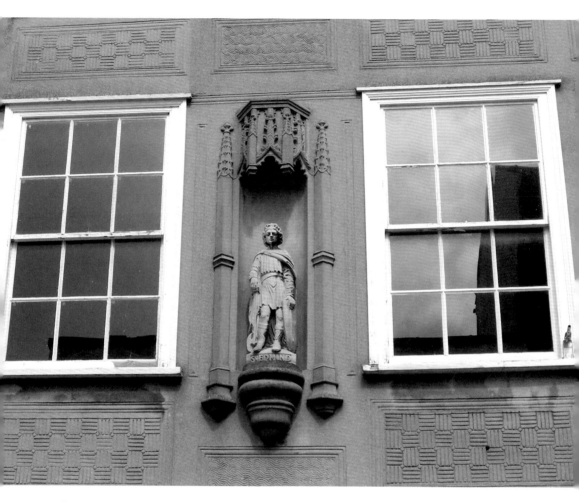

Saint Phocas

No. 2 Abbeygate Street, now the Ivory Bar (2014) was, up to 1969, the premises of Thomas Cross, seedsman, nurseryman and florist. Previously, the business had been across the road at No. 58. Before 1900, they had moved because the Alliance Assurance Co. was to build new offices on the site (now Café Rouge).

A niche above the entrance to the Ivory now contains a statue of St Edmund, looking remarkably like the St Edmund statue on the WHSmith building (formerly Boots) on The Cornhill. The Ivory Bar niche supposedly dates from around 1887, but, previous to the present day statue, there was another saint celebrated here, that of St Phocas, a patron saint of gardeners. It was obviously put there by T. Cross, when is not known.

Phocas was a Christian who lived near Sinope, now in Turkey on the edge of the Black Sea. A kind and generous man, he shared his crops with the hungry poor.

About AD 300, the Roman Emperor Diocletian, who had been persecuting Christians, sent soldiers into the area where Phocas lived. They failed to recognise him when they met, but Phocas knew why they were there. After sharing his hospitality, the soldiers were about to depart the next morning, but Phocas had other ideas. Unbeknown to them he had dug his own grave during the night. He revealed himself and pleaded with the Romans to kill him as it was God's will. Not wishing to carry out their orders, they said they could not kill him, and would say they did not find him. Reluctantly they eventually decapitated him, burying him in his own grave!

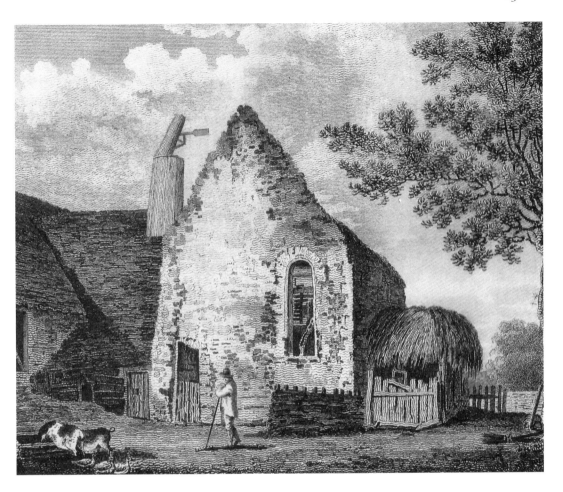

St Botolph's Chapel

The patron saint of travellers, St Botolph, aka Botwulf, was an English saint who died in AD 680. Little is known of this abbot, but he is described in the *Anglo-Saxon Chronicle* and has several churches dedicated to him. King Cnut even had his remains transferred to Bury for a time. In Bury St Edmunds, the Guild of St Botolph used to meet at the College of Sweet Jesus in College Street, which was effectively a retirement home for elderly priests and clergy. However, the Southgate area of the town has a particular affinity with the saint.

Until it was taken down in 1801, St Botolph's Chapel stood in Southgate Street in the yard of the White Hart, now the Abbey Hotel. Southgate Street, a suburb of the town, was a processional way into the town and much used by pilgrims on the way to St Edmund's shrine.

Nearby, St Botolph's Lane was called Yoxfore Lane in medieval times, the adjacent Haberdon being a manor of the abbey. Here, an ancient ritual was played out, with barren women stroking the flanks of a white bull kept tethered here for that purpose. To become pregnant was the optimum result.

In the 1960s, Dr Stanley West identified a medieval stone arch as part of a bridge over the Linnet not far from the site of the chapel; there is also a St Botolph's Bridge in Raingate Street.

There were medieval hospitals in Southgate Street, such as St Petronillas near the Southgate and Domus Dei, not far away from St Botolph's.

Recently, a large number of pieces of limestone, uncovered in the garden of No. 36 adjacent to the Abbey Hotel, have been used to form a dry stone wall there and part of the Wolf statue on Southgate Green.

Churchgate Street Fire

On Tuesday 3 November 1903, the grocery premises of George Rowland Harvey caught alight at No. 45, at 1.40 a.m. in the morning. PC Offord, who was patrolling down Westgate Street at the time, noticed a bright light in Churchgate Street. By the time he arrived at the scene there were flames shooting through the roof of the ancient property. He alerted residents nearby, including Mr Edward Bloomfield, whose boot manufacturing store was adjacent. Edward rushed upstairs and grabbed his sleeping nine-year-old son Stanley.

Fortunately for the fire brigade who, according to reports, were very efficient, there was plenty of water to be had from hydrants nearby. They were able to prevent the fire spreading into the boot shop, and down the street, to a taxidermists run by a Mr Travis but Harvey's Stores were gutted.

Both the boot shop and the grocers were insured for loss of stock and damage to buildings, but Mr Travis was not and the cause of the fire was unknown.

At the time, the conflagration was likened to the great fire of Bury in 1608, more than a slight exaggeration. The rebuild of the premises was carried out in a mock Jacobean style with black painted beams, a look that over 100 years later still confuses people who think it is genuine. At one time, a similar style was used on both The Fox and the Dog and Partridge.

In 1925, Marlow & Co., a timber and builders' merchants, purchased a former almshouses in College Street as stores, the site linking round to No. 44/45 Churchgate Street, which later were to serve as their showroom for bathrooms and sanitary ware. Marlows moved to a new site in Hollow Road in 1973/74.

A Right Royal Fire Mark

High up on a wall, dividing Nos 19 and 20 Abbeygate Street, is this fire mark, a vestige of when this building owner insured the property against fire in the nineteenth century. Before the advent of municipal fire brigades, by insuring your property with an insurance company you could use their fire brigade within the town. In Bury's case, it was stationed in Whiting Street.

The Royal Insurance Co. was founded in 1845 in Liverpool, hence the liver bird. Similar to a cormorant, it is holding a sprig of broom in its beak, the broom being the symbol of the Plantagenet family that had ruled England. The Latin for broom is *Planta Genista*, and that's where the family name originated. A member of that dynasty, King John had granted Liverpool its charter in 1207.

No. 20 Abbeygate Street, W. H. Collis & Son was probably the oldest business in the town. A Mr Collis opened a jeweller's here in 1805, although the property itself dates from around 1720. It has a flying freehold with No. 19. Maybe the premium paid to the Royal was by a member of the Collis family protecting their investments. The shop front was designed by a London shopfitter in 1897. At the same time, the display cases still in evidence up to 2012 were installed!

The trading name of Collis continued with its purchase in 1921 by William Miles, passing to his daughter and then onto her son Peter Aves. He was one of the last owners of a business in Bury to occupy his shop premises. Sadly, after a botched burglary, he was murdered here in 2012.

The fire mark was restored in 1984 by Chelmsford Technical College, at the behest of Brian Jenkins, the then manager of the Anglia Building Society at No. 19, now Corals Bookmakers.

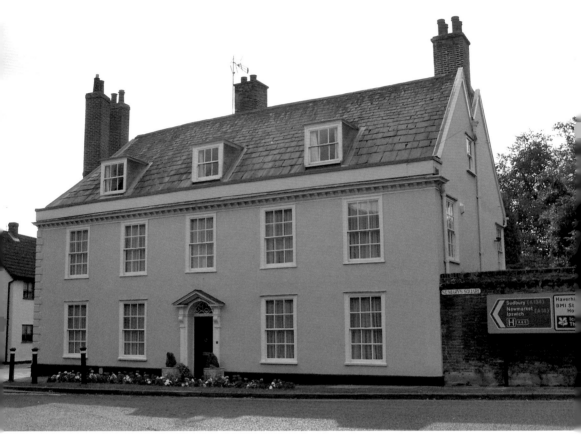

Collyweston Roof Tiles

This unusual roofing tile can be found on properties in Bury St Edmunds. Nos 51 and 52 College Street share one continuous roof. Originally from the mid-sixteenth century, they have a timber frame, with Suffolk white bricks added in the nineteenth century.

The other more substantial property is No. 8 St Mary's Square, once the home in recent times of Bernard Tickner, a director of local brewer Greene King, who was responsible for introducing their flagship ale, Abbot Ale.

This Grade II building dates from around the seventeenth century, but its timber frame has been plastered. The listing describes the roof as having 'graduated tiles'.

Why Collyweston roof tiles were used in Bury is not known. Suffice to say they are extremely durable but require a better prepared roof, as the battens have to be spaced according to the tile size. It is these sizes that they are known by in the trade. Starting at the bottom you have, from the largest: Kings and Queens, then Empress and Small Empress, Princesses, Duchessses, Small Duchesses, Marchioness, Wide Countess and Countess, Wide Viscountness, Wide Ladies, Broad Ladies, Ladies, Small Ladies, and finally, Narrow Ladies.

Though erroneously called Collyweston roof slate, they are in fact taken from fissile limestone blocks that are quarried and left to weather outside. Water is poured over them, and what the frost doesn't split, man then finishes off.

Fissile means capable of being cleft or split. This limestone from the Jurassic period, 140–190 million years ago, is found at Collyweston on the Northamptonshire border, not far from Stamford. It was here they were used to supposedly lessen the risk of fire!

Lloyds Bank Sign

This building in Buttermarket was built in 1796 by banker Robert Carss. He went bankrupt in 1797 after the Bank of England suspended the payment of specie (banknotes against gold coin). This followed a land speculation bubble that had burst in the USA amid fears of a French invasion.

The hanging sign outside Lloyds Bank is special. It has three major components – two pineapples, one on each side.

This heralded from a time when the pineapple was an extremely expensive and rare fruit, and to offer it to your guests showed your prosperity and generosity.

Secondly, on top is an oak tree for the Oakes family. James Oakes had founded a successful banking business in the late eighteenth century, and with his son Orbell it became the Bury & Suffolk Bank in Buttermarket. Orbell's son, Henry, became involved, and the bank eventually merged with Brown Bevan & Co.

Thirdly, there is a beehive, with a bee argued to stand for Bevan of the Rookery in Rougham, which later became Ravenwood Hall. It is more likely that, when Lloyds formed in 1765, after a Samuel Lloyd II and John Taylor set up a bank in Birmingham, they chose a beehive to represent industriousness.

In 1865, Lloyd & Co. ended the Taylor connection, taking over another bank in 1884 that had a black horse as a symbol. In 1918, they acquired the Bury firm Capital & Counties Bank, which had combined a few years earlier with Oakes, Bevan, Tollemache & Co.

Interestingly, while the Okehampton branch of Lloyds has a sculptured stone beehive on the wall, Bury St Edmunds has the only branch in the country without a black horse.

Medieval Artwork

Most of the properties that escaped the great fire of 1608 in Bury are on the south and south-west of the town. Many of these have been given new façades. This is the case at No. 83 Whiting Street, a timber-framed house from the sixteenth century, now a B&B. Yet this house has something very special in one of the ground-floor rooms, a medieval wall painting dating from around 1530. It was discovered when the wall it is on (once a partition wall with No. 84), was uncovered following the removal of false walls in front, one of which was put up in Jacobean times.

During the latter part of the eighteenth and early nineteenth century, No. 83 was lived in by Thomas Warren Snr and Jnr, both cartographers. The name Warren keeps cropping up in this book, as the father produced fine maps of Bury St Edmunds.

The 8 ft by 10 ft medieval painting has diagonal stripes of red-and-black paint, with what looks like a thistle and flowered design. There is some text that is faded and indecipherable, with the painting running across the black, upright beams. A few years ago, an expert said it was very rare – a domestic and sophisticated wall painting. Another authority on this type of decoration said the design could have been copied from an Italian textile or tapestry. Considering its age, the painting is in remarkably good condition, which is probably because the wall it is on is over a dry cellar. Advice was given by the experts as to how to preserve and conserve this wonderful relic of the past. Thankfully, the painting has an owner who appreciates not only this but Bury St Edmunds too.

Zodiac House

This house has been referred in the past as a fine example of medieval pargeting, fine yes, medieval, no. Zodiac House was built by Ernie Warren whose family were local property owners and quality builders.

In 1962, when 'slum clearance' was taking place in the town, Ernie purchased two cottages that stood here, Nos 52 and 53 Whiting Street, and were in a dilapidated condition. The price paid was an astonishing £40 and £60.

Ernie employed a local architect to draw up plans for the work ahead and contemplated running in tandem the reconstruction along with his own work for the family business.

A short while later, Watson's timber yard in Southgate Street asked if he would undertake the demolition of two cottages that Watsons owned in Maynewater Lane. Ernie agreed free demolition in exchange for the building materials, knowing exactly where to use them. Decision made, work started in Whiting Street and took six years. The existing door was found in a cellar and reused. Six wells were also found in the garden.

The fantastic pargeting, with twelve signs of the Zodiac, was carried out by Ernie's then wife, Carol. When it came to having the building work signed off by the council, there was a major problem. What was in front of the council official bore no resemblance to the submitted drawings? A rather glib remark followed: 'Well, you will have to take it down.' 'Like hell,' was Ernie's reply, 'that's over five years of my life there. I'll take it to appeal.'

This he did. The inspector came from London, took one look at No. 52 (only one house by then) and said, 'Why can't the rest of the street look like this?' Enough said! Ernie lived here for about ten years, and after a few years of rental sold it in the late 1980s.

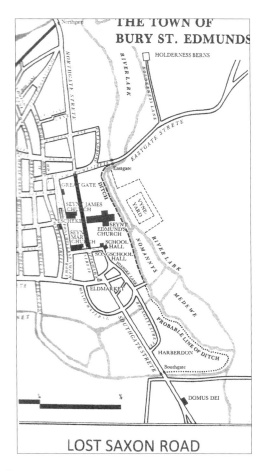

LOST SAXON ROAD

The Lost Saxon Road

Bury St Edmunds was once called St Edmunds Bury, or Burg, meaning a fortified town Previous to this it was Bedericesworth, or variations of that spelling. The meaning being 'The worth or homestead of Bederic.' Who he was is unknown, but it is thought that King Sigeberht, a Saxon convert to Christianity in the early seventh century, and king of East Anglia, had a royal villa or palace here.

Before the Norman Conquest, Abbot Baldwin, of St Edmundsbury abbey, laid out the town grid in 1065, arguably the oldest, purposely laid out town in the country, with today's Northgate Street known as High Street. It is believed that a Saxon road went from here across what we know today as the Abbey Church West Front, into Sparhawk Street and St Mary's Square, and then onwards down Southgate Street.

The building of the Abbey church meant the west front encroached onto this road; therefore, a new road was created to go around the church of St Denys, which stood on the site of the later St James. This road was to become Churchgovel Street, better known today as Crown Street. St James church, along with St Mary's, had their entrances outside the abbey precinct wall to avoid coming under the abbey's control.

In 1914, the Diocese of St Edmundsbury and Ipswich was created, and a decision had to be made where the cathedral was to be located. St James in Bury St Edmunds was selected, as it could be extended. The removal of its Victorian chancel allowed Stephen Dykes Bower, the architect for the Diocese, to proceed with a new chancel, quire, song school, refectory, offices and lecture room from 1960 onwards. It was during some of these works, when an archaeological dig was being carried out, that the Saxon road was discovered.

Saxon Rise

In 1972, a building site on the west of the town near Westgarth Gardens was well under way. A combination of houses and chalet bungalows were being built by Decmar Properties, under the guidance of foreman Jack Gladwell.

As the site progressed on the south bank of the River Linnet, an Anglo-Saxon cemetery was uncovered. Work stopped and the archaeologists moved in. It was soon realised that this was no ordinary burial site, like those that had been discovered in Northumberland Avenue and Barons Road.

Altogether, sixty-eight graves were discovered, dating from around the early fifth to the seventh century AD. Nearly all were burials instead of cremations, both Pagan and Christian, reflecting differing beliefs as time progressed.

One grave stood out from the rest – No. 62. It contained the remains of an adult male, and some remnants of assorted weapons, but the most outstanding of grave goods was a beautiful pale, green glass bucket in near perfect condition.

The small bucket with two handles was described as of exquisite workmanship, similar to earlier Roman glass vessels. The bucket went on loan to Moyses Hall museum, with some other finds from the site, but was sold at auction in 1977. The British Rail Pension Fund, who had purchased it, kindly then let it go back to Moyses on loan. Eventually, it went back to the saleroom in 2004, where it sold for an astonishing £116,650 including premium at Bonhams.

Appropriately the housing site is called Saxon Rise and Long Meadow. Questions were asked for many years after. Were any graves missed, or are any under some of the properties? Decmar went on to build Paddock Close just off Westley Road, where unsurprisingly nothing was found.

Ventilation Pipes

The Bury St Edmunds Paving and Improvement Commissioners were instrumental in getting a proper way for the disposal of sewage. Right up to the middle of the nineteenth century, some people were still having their 'night soil' collected by cart for farmers to fertilise their fields.

With new powers under the local government act of 1858, and the public health act of 1848, new properties within the town had to be built with drains and toilets.

By 1858, there were sewage pipes in the town leading to The Tayfen, near to where the town's gasworks were; however, this was not satisfactory because of the smells emanating from there. Five years later, a new filtration plant at Bell Meadow, near the River Lark, opened, but complaints still came in.

The period 1885–87 saw a purpose-built sewage farm open at West Stow, however, there was still the old problem within the town – the smells! It was against this background that a solution was sought. Stench pipes were installed to ventilate the sewers, so the smell dissipated up high, and also to allow air in so a vacuum was not created, stopping the sewer from working. A company run by William Edward Farrer of Solihull, near Birmingham, made pipes ideal for the job. With a background in metal design, he had formed Farrer Sewage in 1898. His product was installed in Bury St Edmunds. Whether there were more than the four remaining in the town is not known, but today they can be found in Raingate Street, Friars Lane, by the railway bridge in Out Northgate, and the one shown near the Fox PH in Eastgate Street. Topped by a crown, around 23 ft tall and stable they have served the test of time.

Stinking Rich

In medieval times, upon death it was most desirable to be buried within the church itself to be nearer to God. Chantry chapels enabled the better off to have prayers said for them, the clergy being paid to do so through endowments. The oldest endowed service still in existence from 1481 is that of Jankyn Smyth, plain Johnnie Smith, a great benefactor of the town. A contemporary of his was John Baret, a rich clothier-cum-merchant who lived in Chequer Square.

John Baret inherited family wealth and, from his position in local guilds, he was able to advance his standing in society so much so he married Elizabeth, daughter of wealthy local landowner Sir Roger Drury. When John Baret died in 1467, he left various bequests, including how he wanted his memory kept alive in St Mary's, his parish church. You can still see how he is remembered today. His chantry chapel ceiling, with its mirrored stars looks down at him entombed in his cadaver tomb, although slightly moved from its original position.

Also known as a pardon tomb, a type of gisant or recumbent effigy, it was made during his lifetime to remind him of the frailties of life.

In skeletal form, with a winding sheet around him, it was believed then that if you gave alms to the poor, supported the church and led an unblemished life, the time you spent in purgatory while waiting to get into heaven would be minimal. On the tomb it is written, 'he that will sadly behold me with his eye may see his own morrow and learn to die.' While the body decayed inside the tomb it would give off a whiff, hence the term the 'stinking rich'.

The Visitors Books

Revd Samuel Blackall, honorary canon of Ely Cathedral, lived at Abbey Precincts in the Great Churchyard until his death in 1899.

During the time he was here, he had in his employment a young lady, Anne Youngs. She had been born in Earls Colne, Essex, in 1866, then moved to Lowestoft before coming to Bury St Edmunds.

After the Canon died, Anne Youngs worked for his daughter Laura, until Laura died in 1919. It was during this term of employment, when Laura ran a small guesthouse, that an extraordinary archive was kept at the Precincts. In two volumes, the first relates to the people who attended the Bury pageant of 1907, with names of people from all over the country, including the pageant master Louis Napoleon Parker. However, the second is an incredible document, which has pictures of convalescing troops in the gardens from the First World War. The visiting troops, over 500 of them from all regiments of the British Army and the Commonwealth, signed their names in the book; probably the most famous that of Cpl Sydney Day VC, of the Suffolk Regiment.

When the war finished so did the visitors' books and Anne Youngs retired to live at No. 76 Eastgate Street. During all this time she had been attending services at St James before, and long after it became the cathedral in 1914.

Anne was collected by car to attend a service on Armistice Sunday in November 1962. Unfortunately, she suffered a stroke in the car outside the cathedral. She died a week later in hospital. It is thought she was the longest serving worshipper at St James. Anne is buried in the churchyard of St John the Baptist Church at Lound, near Lowestoft.

Subsequent to her death, the visitor's books were found among her possessions by relatives.

Historic Footsteps

The west front of the Abbey church of St Edmundsbury abbey was perhaps the largest of any Romanesque church in Northern Europe at 246 feet across. It was completed in the abbacy of Abbot Samson by 1210, a fact recorded by a chronicler of the abbey Brother Joscelin, and the most sizable and impressive part of the Abbey church to survive. The western tower, rebuilt after a collapse in 1430, must have been pretty spectacular along with the rest of the west front – four chapels and octagonal towers at each end with three entrance archways between them. After the Dissolution in 1539, houses started to be built into the west front. They were to become a bone of contention through the latter half of the twentieth century. Should the houses be removed? After a visit by Lord Montagu in 1987, chairman of the English Heritage commissioners, it was decided that the way forward in preserving the west front was to restore the houses. However, St Edmundsbury Council (the owners) and English Heritage prevaricated so much that the west front went onto the building at risk register. Eventually, developers came forward and a fine restoration was completed by 2008.

Nearing completion, a remarkable find was uncovered high up – a trackway was found in the stone. It was created by monks over 500 years ago, their hobnailed sandals eroding the access to the levels above.

With the houses fully restored, and the track protected for future generations to appreciate, it was time to reflect whether to restore or to unpick the houses to reveal the ruins. As part of history in their own right, the houses thankfully won.

The Ops Room

The Guildhall is owned by the Guildhall Feoffment Trust, a charity surviving from medieval times. Recently uncovered archaeological evidence suggests it may have its origins in the twelfth century. This fine building has been serving the townspeople in a civic capacity for many years; council meetings, courts and receptions have taken place here.

Hidden within the Guildhall is a more modern feature: An ops room from the Second World War, which, until recently, was the Scout and Guide shop.

With the war looming, it was vital Britain could trace the first onslaught of an invasion from the air. Spotting enemy aircraft, either physically or by radar, was very important so combative measures could be taken. This is why this Royal Observer Corps station, partly manned by local civilians, was vital to the war effort. Connected to the radar station at Trimley Heath near Felixstowe, aircraft movement information could be sent directly to Bury to plot details of airspeed, course and height on a map of Eastern England, which would help to contribute to the bigger picture developing overhead.

When the war ended, the ops station continued to be used for training purposes until the 1960s. The advent of the Cold War meant a new underground concrete bunker, manned by the ROC, was built in 1962 at Westley to combat a different threat. It is still there unused, under a school playing field.

Thankfully, the Guildhall ops room, although devoid of its equipment, is still evident today, and is probably the last of over forty such rooms in the country. The Guildhall Project has plans to create a heritage centre here, and to reinstate equipment into the ops room. This room is a unique reminder of some of the darkest days our country has faced.

HMS *Birkenhead*

At the side of the North Aisle of St Marys church, there is a marble monument with the wording: 'A deathless story. To the glory of God and in memory of the men drowned at the wreck of HMS *Birkenhead* on 26 February 1852.' There are fifty-five names, all privates, followed by, 'Erected by the officers past and present, NCOs and men of (12th) The Suffolk Regiment.' The last port and call for the Birkenhead was to be Port Elizabeth, where these soldiers and others from different regiments were to disembark. As the ship, a steam frigate, rounded the Cape of Good Hope, South Africa, she struck an uncharted rock. Maybe its captain, Robert Salmond, was sailing to close to the shore. Suffice to say, the ship started sinking quickly. He gave the order for those who could to save their lives. However, Col. Seton, the officer in charge, made it clear that, if they rushed to the only lifeboats, fifty or so women and children would be lost. The men, some in a state of undress lined up to attention as the lifeboats with the women and children left the stricken ship. No one broke ranks. As the ship sank, some men managed to swim to shore but many suffered the horrible fate of being eaten alive by sharks. Of the 643 people on board, only 193 survived. In Cape Town's naval museum, there are many poignant mementoes that have been brought up from the wreck, including cap badges. Whether the order of 'women and children first' was ever issued is unknown, but today it is recognised as The Birkenhead Drill.

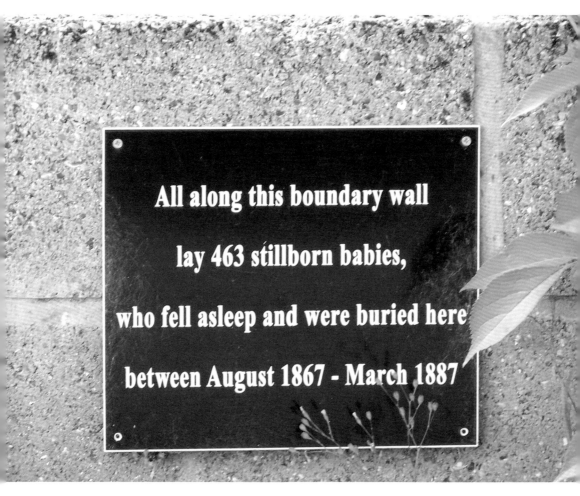

All along this boundary wall

lay 463 stillborn babies,

who fell asleep and were buried here

between August 1867 - March 1887

Tragic Burials

Bury St Edmunds Borough Cemetery opened in 1855, divided into what is known as Compartments (designated areas). It is now approaching full capacity. Long before cremations were the norm, burials were mostly with headstones. One area has no markers, for along a boundary wall on the cemetery south side, in Compartment One, there are 463 babies buried between August 1867 and March 1887. These were stillborn, their mothers local people, in many cases unaware of what happened to their offspring that they failed to carry to full term (twenty-four weeks plus), or failure of the baby to draw one breath. The babies were removed by the midwife or doctor, in many instances not allowing for any grieving process to take place. Many of the births in the nineteenth century were at home, and perhaps a lack of hygiene or expertise may have contributed to stillbirths, but there was also a high proportion in the hospital as difficult pregnancies were dealt with there.

Since 1 July 1837, all deaths had to be registered the same way as births and marriages, but not until 1874 were death certificates required for a stillborn child to be buried. The compulsory registration of stillbirths was not until 1927.

Surprisingly, the population of the town expanded by 25 per cent between 1861 and 1891 to 16,630, with local industry contributing to this growth; Bury had also added a third parish. Most churches only recorded the death of children that had been baptised, something these babies never received. However, they are not forgotten because Sue MacDonald, the cemetery registrar for St Edmundsbury, had this poignant plaque put on this wall in memory of them.

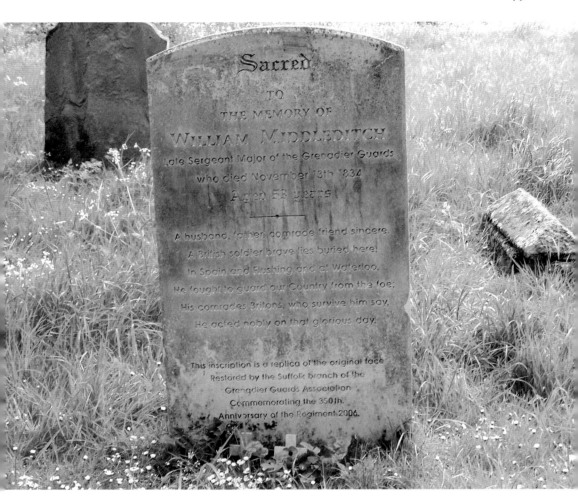

A Veteran Soldier

In 2006, a headstone in the Great Churchyard was restored to an extraordinary man, that to William Martin Middleditch RSM. He was born in Hawkedon in 1781 although many of the family ties were in Bury. As a twelve-year-old, he became apprenticed to a builder eventually becoming a bricklayer.

When William was nineteen, the 1st Regiment of Foot were recruiting in East Anglia, and he enlisted with them knowing that this would be until he died, probably in battle or discharge through illness or injury.

With the Napoleonic Wars raging, taking the 'Kings Shilling' was a serious career move, some recruits joining of their own free will, others while drunk or pressganged. It would seem that William led a charmed life on the battlefield, fighting in several battles against the French army across Europe. Whether he fought in the battle of Leipzig, which saw Napoleon exiled to Elba in 1813, is not known, but he certainly fought in Napoleon's return and last battle, Waterloo, in 1815. William and his comrades received battle honours, the regiment itself being renamed The Grenadier Guards.

Within a year, he had been promoted to sergeant major and, on his return to England, married in St Mary's church in Bury. However, this battle-scarred veteran of over twenty-one years was invalided out of the army in 1822. He purchased the Ram PH in Eastgate Street, mine host until his death on 13 November 1834.

At his funeral, the pallbearers were six former comrades-in-arms who had served with him, the last line of his epitaph summing up their feelings: 'He acted nobly on that glorious day.'

Fennell Homes

Also known as the Quaker homes, Nos 57–59 St Andrews Street North were the first purpose-built flats in Bury St Edmunds.

Brother and sister Samuel and Sarah Fennell, were Quakers and lived at No. 2 St Mary's Square. Notorious for their tightness, it was not surprising that, when they passed away, they left a considerable sum of money. The main beneficiary was another Quaker, Sarah Bott, who resided with them. The Fennells would have turned in their graves if they knew what she intended to do with 'their' money. Using this legacy, she set up a charitable foundation, The Fennell Trust, with which new homes would be built for respectable women in reduced circumstances who had some income of their own. They also had to read the bible to the poor. Early in November 1870, she arranged for plans to be drawn up by an architect, who had the somewhat colourful name of Brightwen Binyon. In August 1872, land at the rear of The Quaker Meeting House in St John's Street was given to her for the project.

However, she met opposition from her brothers, James and William Bott, who tried to get her declared insane, but, with the help of a good friend, Samuel Maw, from Needham Market, she weathered the storm.

By 1874, the work was completed by Bury builder Mr Tooley, with the first resident, Mary Ann Rudderham, moving in soon after. Sarah made a will safeguarding the future of the homes, leaving a bequest to her sister Mary, and gave the others nothing. Sarah later moved to Hatfield Peverell, where her family lived. Today, The Fennell Homes are run by the Guildhall Feoffment Trust.

Art Deco Bury

Bury St Edmunds has but two buildings that could be described as Art Deco. This style of architecture was espoused by some architects between the two world wars. With narrow tall windows and doors, geometric shapes and lines, it was definitely a statement of design.

Greene King was to follow this design to some extent with the building of a new Brewhouse in Westgate Street, which opened in January 1939. Collaboration between chief engineer Mark Jennings, brewery architect Bill Mitchell, and head brewer Col. Oliver allowed this problem project (lack of certain building materials and piling of footings) to be finished.

Certainly the other candidate for an arts-and-craft design building was that of the former Burtons Shop on Cornhill (in 2014 the Works). Hunter & Olivers, wine merchants, owned a double shopfront on Cornhill, one they retained for themselves (now Boots); the other was rented to Burtons the Tailors. They rebuilt the shop in the Art Deco style. In 1933, black marble foundation stones were laid by Stanley Howard Burton and Raymond Montague Burton, both sons of founder Montague Burton. Sunburst patterns in niches are above the three tall, metal-framed windows in the classic number of three, everything that is symptomatic of Art Deco.

Born in Kovno province, Lithuania, in 1885, Moshe David Osinsky came to Britain in 1909 to seek his fortune. He changed his name to Maurice Burton, then to the grander Montague. He died in 1952. Burtons were among the first tailors to make affordable suits to all. As was common with many of their shops, a snooker hall was situated above, and many lads had a misspent youth there.

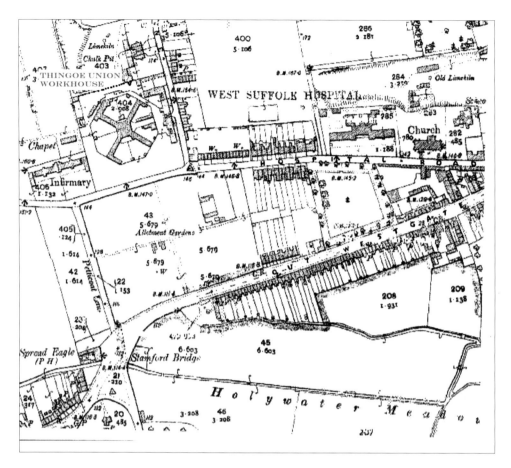

In the Workhouse

Pauper management was a burden very few parishes could cope with. The Poor Law Amendment Act was passed in 1834, allowing these victims of poverty to be treated in a more humane way by the standards of the day. Bury already had a workhouse in College Street, but with the Thingoe Poor Union now in place enabling parishes to join together, another workhouse was built. Thingoe was one of the ancient hundreds that formed West Suffolk, its parishes sending forty-five members to form a Board of Guardians.

In 1836 in Mill Road, on the western side of the town, the new workhouse, a large, red brick edifice, was built by William Steggles and cost over £6,000; it had room for 300 paupers. The number of these wretches in the 'spike' in 1851, was 250. They were so named after the tool to unpick ropes for oakum, one of the least favoured jobs given to inmates. Infants were kept with their mothers and the older children were put to work, as everyone had to work to pay for their keep. The diet was very basic, Oliver Twist days!

In 1878, inmates from College Street (sold off in 1884) were moved to Mill Road, the two workhouses merging to become The Bury Union, eventually the Thingoe Union Workhouse, in 1908. In 1898, part of the building was an infirmary, the shape of things to come, as, in 1930, it was given over to become St Mary's geriatric hospital.

The stigma of being born in a workhouse stayed with some people all their lives. The memories of a childhood there sadly stayed with the elderly until their death in the very place they were born. The geriatric unit moved out on 18 April 1977, with St Marys demolished in 1979. Housing is now on the site.

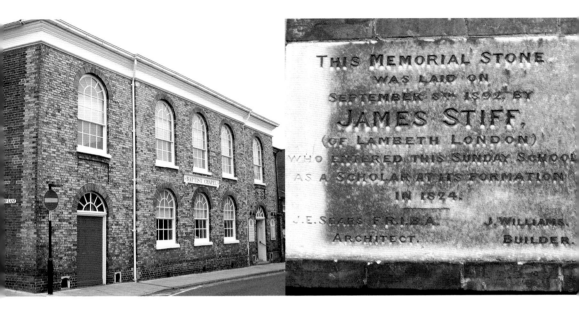

James Stiff

Born in 1808 at Rougham, James was the son of Robert Stiff, a workhouse master and farmer. In 1831, he married Sarah Faulkner Philpot and then Lucy Potter in 1878, both names strangely connected to his career choice of pottery.

He entered a Baptist Sunday school in Bury St Edmunds as a scholar, at its formation in 1824, returning on 8 September 1892 to lay a foundation stone for a new Sunday school.

In 1826, James left his job as a plasterer's assistant in Rougham to begin working as an apprentice at the Coade stone manufactory. Eleanor Coade had perfected terracotta to be used in an external situation. The Coade Co. closed in 1843. Mark Blanchard, responsible for the wonderful terracotta planter in St Mary's Square, purchased many of their moulds. It was as a mould maker that, in 1830, James Stiff started work at Doulton & Watts Pottery, leaving there to work as a potter at his own premises in Ferry Street, Lambeth.

Both businesses, Doulton and Stiff, were famous for their many types of stoneware pottery. Doulton coincidentally went on to make Greene King plaques; Stiff made vibrant, colourful pottery. His two sons, William and Ebenezer entered into partnership with him in 1863 the company becoming James Stiff & Sons. Strangely the name Ebenezer was applied to many Baptist chapels, including the Garland Street chapel in Bury St Edmunds, when it was built in 1833 on the site of a previous chapel. James, an ardent Baptist, also built six almshouses at Rougham on family land.

In 1895, he retired, leaving three relatives to run the company as a partnership, this being dissolved in December 1912. A year later, it was sold to Royal Doulton. James Stiff died at Swanage in 1897, and is buried at West Norwood Cemetery.

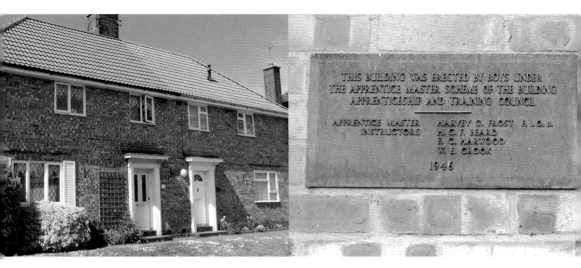

H. G. Frost

Henry Frost was a builder and contractor of No. 8 College Street established in 1834. Henry Jnr, his son, advanced the business acquiring premises in Out Westgate in 1875, the yard of Lot Jackaman, builder of the Corn Exchange.

Henry's son, Harvey George Frost, took over in 1920. As a reputable builder, some of his major builds were the Marjory Blyde nursing home in Hospital Road, Burtons Shop on The Cornhill, the Sugar beet factory, and a new outpatient department at the West Suffolk Hospital.

He also carried out the Theatre Royal Restoration. Greene King, who had been using it as a barrel store until 1959, let it go on a peppercorn lease to The National Trust for 999 years; it re-opened 1965.

H. G. Frost was a pioneer in further education for building trade apprentices. The scheme he started led to the first permanent education centre at the Silver Jubilee Boys' School in Grove Road, now KEGS. It moved to Risbygate Street in 1959, now the college. He was also instrumental in instructing apprentices to build two sets of semi-detached houses on the Mildenhall Estate just after the Second World War. This estate was the first development outside the town's medieval boundaries.

Harvey, who lived at Stonebridge, Horsecroft Road, became chairman of the school governors and then chairman of West Suffolk College, and president of several organisations associated with building. He received an OBE in 1952.

He died aged eighty-one and his yard was then sold to R. G. Carter of Norwich in 1974. They still have it at No. 30 Out Westgate. H. G. Frost Builders, now in its sixth generation, is still active in the Bury St Edmunds area.

Two Birds

The two rivers that flow through Bury St Edmunds are the Lark and the Linnet (as pictured). The Lark, a tributary of The Great Ouse rises to the south of Bury, the Linnet out at Ickworth. The two of them converge near the tennis courts in The Abbey Gardens (2014).

Previously, the Lark was known as the Bourne and the Burn, the Linnet, at one point, the Maidwater. Both have played significant parts in the history of the town. During the days of the abbey, some of the Lark's waters were diverted to form fishponds or crankles so that the monks could have a constant supply of fish. Also diverted was the Linnet, a watermill sat astride, grinding the townspeople's grain, with a tax being charged for this service.

At one time, the Lark was hoped to be navigable to Bury; a scheme that finally floundered at the beginning of the twentieth century. The Abbey Gardens suffered flooding in 1879 when a grand gala was postponed. However, this was nothing like the great floods of 1968, when many parts of the town were underwater following torrential rain. Eastgate Bridge was blamed, built in 1840 by the respected family of W. Steggles & Son. The subsequent inquest stated that it was not fit for purpose for today's usage. However, rumours soon spread that the then 6th Marquess of Bristol had exacerbated the situation by ordering the sluices at Ickworth to be opened to protect the fish stocks in his lake. The engorged Linnet flooded the Stamford Court area, and subsequently the Lark in Eastgate Street by the Fox.

Measures such as widening the banks of the Linnet, and re-enforcing the banks under Eastgate Bridge (now listed), will hopefully ensure this catastrophe will not happen again, providing the sluices are kept shut.

The Priors Estate

The former name of Westbury Avenue was Priors Lane. The footpath running from Westley Road, right up to the Boyne Road of today, was known as Priors Footpath, as shown on a map of 1885.

After the Victorian and Edwardian town expansion, which finished at West Road, consideration was given to building a new housing estate belonging to Bury St Edmunds Corporation.

Some of the land the Priors Estate was to be built on was owned by Perry Barn Farm, as shown on Payne's 1833 map of Bury. The building programme started in 1928, the site soon acquiring the sobriquet 'Hill 60' due to its resemblance to a First World War battlefield. Priors Road and Avenue, along with Perry Road, were the first to be built, followed by Boyne, Linnet and parts of West and Abbot Road.

Post Second World War, prefabs were built at the end of Perry Road and Perry Close (now Beaumont Close). This was part of a council initiative to address a housing shortage, with other prefabs being built in East Close, Queens and York Close. All these survived well past their sell-by date. Over 270 houses were built on the Priors; many were refurbished in the early 1980s by George Grimwood & Son from Sudbury. A change of names followed: Perry Road became Ashwell Road and Priors Road became Brocklesby Walk. The Priors Stores, once much used by residents, eventually closed through economic circumstances.

Whether the same could be said for The Priors Inn is debatable. This large PH opened in 1933, its licence transferred from the recently closed Horse & Groom in St Andrews Street South. With the closure of the Priors Inn in 2014 (the site destined for housing), the community has lost a valuable asset.

The Bells, The Bells

During his abbacy of 1120–48, Abbot Anselm was responsible for building the religious gateway to the abbey, now known as The Norman Tower. Constructed in limestone from Barnack Quarry on the Northamptonshire border, it is 80 ft high with 6 ft thick walls. Perhaps the most famous procession to go under its archway was in 1533, the funeral cortege of Mary Rose Tudor, Queen of France and later Duchess of Suffolk. This was six years before the Dissolution of the abbey by her brother, Henry VIII.

Several changes have taken place over the years to the tower. A tympanum, a semi-circular membrane over the archway, facing up Churchgate Street, was removed in 1789 to allow traffic to go through. There is neither a clock (removed 1897) nor a cupola on the roof (removed 1845). Something that always intrigues people, is the ground level at the Norman Tower, which is lower than the surrounding area. The levels at the tower are original and it is the surrounding area that has built up over centuries.

Had it not been for the specification for remedial works drawn up by architect Lewis Nockalls Cottingham, and put into practice in 1846/47 by his builder, Thomas Farrow, we would not have one of the finest Norman structures in the country or the belfry for the cathedral.

A fantastic ring of ten bells were put up in 1785, the only complete set ever to be installed in one go. They were cast at the foundry of Thomas Osburn at Downham Market, the heaviest weighing over 1.5 tonnes! In 1972, the bells were hung 12 feet lower, in their original wooden frame. Recently, three more bells were added, two in 2012, the other in 2013. The bells are rung by The Norman Tower Bell Ringers.

An Enlarged Chapel

This was a Rehoboth Baptist chapel erected in 1840 at a cost of £800. The strange name of Rehoboth comes Genesis 26:22, when Isaac ordered a new well to be dug because of disputes over who owned the wells. When the new well had been dug, Isaac called it Rehoboth and said, 'the Lord has given us room and we will flourish in the land'. In that context it would seem that this name means enlargement or expansion relating to the Baptist church. The larger Garland Street Baptist church was built six years earlier, but some members disagreed with the charismatic pastor, Cornelius Elven, as to the interpretation of their faith, hence the chapel in Out Westgate.

When the chapel became redundant is not known, but, in the 1970s, the *Miro Press* was here for many years before moving on to Western Way. The next incumbents were Rees, Prior & Associates Architects, purchasing it in 1989 from The Evangelical Trust, when it was known as Mount Zion House. The place was modernised into four self-contained business units and an extension at the rear added. At this time, a story concerning one of the draughtsmen working late at night came about after a couple of graves were found. Although left *in situ*, it would seem that the occupant of one didn't take kindly to the building work, as the architect sitting at his desk late at night felt a chill in the air as if someone was watching him!

After Rees & Co. left in 2009, it eventually went back to its origins of evangelism. The West Suffolk Vineyard church, which meets at the KEGS school in Spring Lane for Sunday Services, has its offices here.

Methodical History

St Marys Square, previously listed as The Horse Market, was once the main market of the old Saxon town. A house here was owned by Hannah Jewers, a devoted Methodist. Her name was misspelt in a licence granted for preaching in the house in 1766 to Jervers!

By 1780, a Richard Cooper lived in part of the house, paying Hannah and her sister Elizabeth rent, although they still occupied some of the property. John Wesley, founder of Methodism had been to Bury St Edmunds several times to preach in the open air, or in private houses, such as in Church Walks.

Richard Cooper and the Jewers sisters had died by 1809, the house passing into the ownership of trustees who demolished it to build a chapel, which was opened for worship in February 1812. The size was 41 ft by 30 ft, with galleries on three sides and a high ceiling.

While construction took place, Sunday services were conducted in the Presbyterian chapel in Churchgate Street (now Unitarian). Wesleyan Methodism was strong in the town, which had 132 members, but there had been a schism in the movement when the Primitive branch was created in 1810 over the wish to return to 'grass roots beliefs'.

As the century progressed, a larger Methodist church was built in Brentgovel Street, now known as The Trinity Methodist church after the three branches (inc. United) amalgamated in 1932. The St Mary's Square chapel was sold for £315 in 1878.

From thereon it was used in many ways: a seed dressing area for a local mill, a school woodwork centre and even a corset factory. An even more unusual use was that of an ice cream factory when it was owned by the Stockbridge family. In later years, Edmondson Electrical had it as a warehouse until it eventually became a private house, No. 4a St Mary's Square.

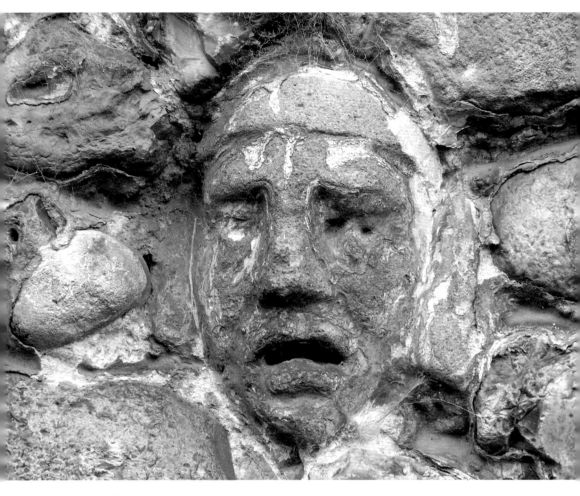

A Face In Torment

Where this stone carving came from is anybody's guess – maybe the despoiled abbey? This face has ended up in a flint wall in a barn at the rear of No. 52 Abbeygate Street. The barn is part of the curtilage of the Grade II listed building, until recently it was a branch of Barclays Bank, and is now Côte Brasserie. It was brought to my attention a few years ago following the closure of Barclays amid concerns for its safety. It was asked whether any work would be carried out to safeguard it. Well, after inquiries were made, it seems it will remain undamaged. It has been untouched and unnoticed for years. I wonder who put it there and why?

This building was built in two phases, the eastern half in 1856 for the Norwich bankers, Gurneys. They were there until 1880, when it then moved into the western half, which was designed in a matching style. Gurneys were founded by two Quakers, John and Henry Gurney, in 1775. Barclays Bank took over Gurneys in 1896. The eastern half of this was also the Bury Registry office for many years.

During the latter part of the twentieth century, Barclays took over the whole of the premises, recently moving to The Cornhill.

One thing is certain – the barn predates No. 52 by many years. It is thought at one time it was a blacksmiths. There are limestone blocks edging the flints in places, obviously from the abbey. Is there a similarity to that of the head of St Edmund on the Frink statue on the green by the side of the cathedral? This wonderful work of art was erected in 1976 to acknowledge the amalgamation of West Suffolk with East Suffolk, becoming the County of Suffolk in 1974!

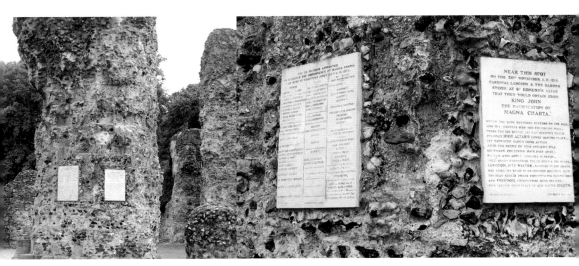

A Learned Man

John William Donaldson, born in 1811, was the son of a merchant. He was educated at University College, London, and excelled at philosophy and the classics. He upset some theologians of the day with his viewpoint on parts of the Old Testament. When the headmaster of Bury Grammar school, John Edwards, resigned in 1841, J. W. D. was appointed. Perhaps his greatest involvement was in the 300-year celebration of the grammar school in 1850, known as the Tercentenary Commemoration. In other respects he was not the ablest of Heads, but did like to associate with fellow Bury literary acolytes such as Henry Crabb Robinson and William Bodham Donne.

Twice married, at times he was careful of spending the school's money – one particular time the boys were deprived of fires in their rooms. Whether it was a result of his upbringing is not known, but it may have had something to do with it. It was against this background of austerity, combined with his unsympathetic attitude to the pupils, that school numbers began to fall.

Although it must be said, he rarely administered corporal punishment, that was left to the more senior form boys.

With attendance from boarders at an all-time low, he resigned, taking up a post in Cambridge as an examiner for the University of London. In 1855, at his mother's London home, he was found dead at just fifty-one.

There is a marble tablet in memory to him in the cathedral cloisters, but perhaps his best legacy are the two stone tablets from 1847. He had these put up in the Abbey Gardens to record the Magna Carta events of 1214, when Bury St Edmunds hosted the meeting of the Barons at St Edmund's shrine; 800 years previous in 2014.

The Shambles

From medieval times onwards, this was where the slaughtering and butchering of animals took place. The name most probably derives from the Saxon word 'fleshammels', meaning flesh-shelves, where the butchered meat was put on display.

A famous picture, painted soon after Cupola House was built in 1693, shows The Shambles as a very different area to what it looks like today – a large open space. Most of what we know as The Traverse today was known as Skinner Row, and only a small piece near The Cook Row (today's Abbeygate Street) was The Traverse. At the rear we still have Skinner Street, as near to a medieval street as you can get in Bury. The actual Butchers Shambles stood near to where the Corn Exchange was erected in 1861.

To make way for this building nearly thirty shops, stalls and yards were demolished. However, the seven shambles now at the back of the Corn Exchange were retained. They were given to the town in 1761 by the Third Earl of Bristol, Augustus John Hervey. The Bristol coat of arms is still above the shambles, on the rear of the Corn Exchange. One vestige of the shambles still evident today are pillars and, in between these, are pierced, ornate, wrought-iron grills, which used to let the stench of offal and guts out of the shops.

After they were no longer required, thanks to more hygienic and humane ways in meat processing, the shambles became shops, Glasswells Furniture having a small showroom here for many years, as did Specsavers.

R. Boby Patress

A patress is a tie plate to strengthen a wall. There are several here on former maltings in Mildenhall Road, most have TGC 1851 written on them for Thomas Gery Cullum, the nineteenth-century owner who built as a warehouse.

Just one has 'R Boby, Bury St Eds' written on the plate. Robert Boby started out as an ironmonger in 1843 at No. 7 Meatmarket, now part of Cornhill. He lived with his wife Elizabeth and five children in Blomfield House, Lower Baxter Street (a clinic is there now). His brother, George Boby, ran a coal business on Station Hill, known as Boby Bros, but Robert Boby Ltd was by far the larger business. In 1855, together with a Thomas Bridgeman, he took out a patent for a corn-dressing machine. It was a success and his business took off. A year later, he moved into buildings near to James Oakes former combing sheds in St Andrew's Street South, the site becoming known as St Andrew's Ironworks. Brother George lived nearby in St Andrews Castle. Very soon after, Robert, probably the largest employer in town, had over 200 people working for him, churning out agricultural implements. However, a devastating fire in 1876 severely damaged his factory, not getting back into full production until a year later. Robert died in 1886, leaving a nephew running the company until it was sold in 1898. Boby continued in manufacturing, winning many medals and prizes at trade shows. Eventually it was taken over by the Vickers Group and continued until 1971 when it closed.

Although the ex-Boby administrative offices are still in existence, and the nearby retail park and roadway bears the name Robert Boby, the small tie plate may be the only actual relic left in public view in Bury St Edmunds today.

Behind Closed Doors

No. 79 Guildhall Street, aka Norman House, once stood opposite Churchgate Street, a street now moved over from its original position. According to legend, you could stand here and see a candle lit at St Edmunds' shrine in the abbey. It is called Norman House because behind its front door there is a twelfth-century doorway. Romanesque in design and origin, it has a strong, rounded, stone arch. This building may have been a 'wash and brush up chapel' for pilgrims on their journey's last leg to see Edmund's shrine.

Across the road is the Guildhall, possibly the country's oldest civic building. The oldest record of it is from 1279, though it is older than this. It has a chamfered, early Gothic, stone-arched entrance doorway inside the fifteenth-century porch. On the outside, the porch has the borough coat of arms, on rows of alternate bands of red brick and knapped flints. Above this is a chequerboard of stone and more knapped flints. Behind this façade is a muniment room above, containing a medieval wall safe made of oak and bound with iron straps, once thought to house documents belonging to Jankyn Smyth, a major benefactor of Bury. His endowed service from 1481 is still celebrated. Alderman of the town seven times, he was also a prominent member of The Candlemas Gild, the forerunner of the Guildhall Feoffees. The Guildhall Feoffment Trust still owns the Guildhall.

The Guildhall has two wings, each 55 ft long, with the council chamber on the right used as such until the end of 1966. The former courtroom ceiling, on the left, still shows the ends of arch braces that are in the roof, part of a more elaborate, timbered roof, including a king post that is hidden from view.

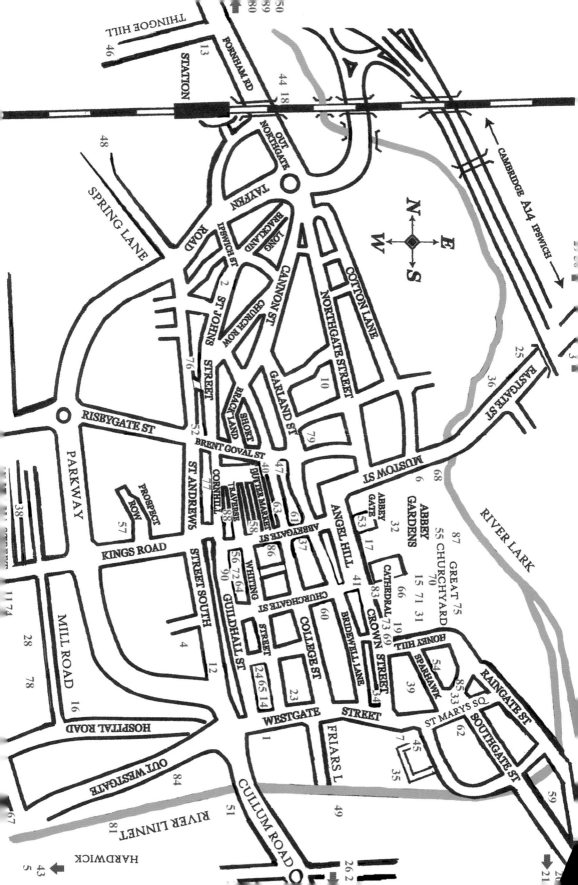